To really see, have your eyes open,
your mind open and your heart open

WITH

design fundamentals

DESIGNING PHOTOGRAPHS

Peter Bonnici | Linda Proud

A RotoVision Book
Published and distributed by RotoVision SA
Rue du Bugnon 7
CH-1299 Crans-Près-Céligny
Switzerland

Tel: +41 (22) 776 0511
Fax: +41 (22) 776 0889

RotoVision SA, Sales & Production Office
Sheridan House, 112/116A Western Road
Hove, East Sussex BN3 1DD, UK

Tel: +44 (0) 1273 72 72 68
Fax: +44 (0) 1273 72 72 69

Distributed to the trade in the United States by
Watson-Guptill Publications
1515 Broadway
New York, NY 10036

ISBN 2-88046-353-X

Book design by Quadrant Design Associates

Production and separations in Singapore by
ProVision Pte. Ltd.
Tel: +65 334 7720
Fax: +65 334 7721

what's in this book and where you can find it

Tibor Kalman

Designer

How to look at photographs should be taught in schools but isn't. There is no course which teaches how to stop and listen to the sounds of an image. It's disturbing that in an image-driven culture no-one knows how to look at images.

What I look for in a photograph is reality. I can understand things in photographs which I can't understand in words or even in films. Historians never describe basic things, but in photographs I can see the shoes and the hair-styles, the expressions, the room. In photographs of the Civil War, or of early Paris you learn a lot more. You learn something new.

When designing '*Colors*' for Benetton I used about two thirds stock pictures to a third commissioned. An editor trying to use photography to tell a story can easily be disappointed by commissioned work. The story you commission is not the one you're going to get. With stock pictures, you can see the photography before you buy it, and you get lots of different choices about the picture. It's like having the work of 10 commissioned photographers. Also, using stock allows you to change your mind. the commissioned photographer may have a disaster, but then, you also have the possibilities from a disaster, which can lead to something fantastic.

Sometimes I don't know what I'm looking for. I use picture researchers a lot. They are briefed to bring in a tremendous amount of images. If I don't look at 2000 pictures a day, I haven't been working.

I haven't seen a picture that I haven't loved. I haven't seen a picture that isn't of value. I haven't seen one which has nothing to tell me. Whatever the image – nasty ads, real estate, prisoners, high school students. There is no picture which does not contain an infinite amount of information.

introduction

Essentially, this book is about looking.

With millions of photographic images all over the world, we would be mad to claim that every style has been explored and a rational conclusion arrived at. With millions of designers and photographers all over the world, we would be mad to claim that the use of photographic imagery in design has been exhaustively explored and a rational conclusion arrived at.

So we've stuck to the broad picture – we ask readers to look.

Everyone looks – photographer, designer, their intended audiences and any innocent passer-by. But what is seen? And does it matter?

Looking transcends nationality, gender, creed and all the other divisive factors in society. It's what unites humanity. But *interpretation* of what is seen can divide people.

On an intellectual level, the image is subject to interpretation. It is seen as a symbol. And symbols vary according to education, culture and so on.

But then there's the emotional level...

Every image also communicates in the secret language of feelings – it makes you feel something. On this level, consensus is greater.

A mixed group of people trying to reach consensus about the extent to which a collection of random images project, say, the quality of 'caring', usually start off by choosing symbols of care like mothers and babies, feathers, protective hands, etc.

But when asked to step back, look at the images and ask: 'Does this **evoke** a feeling of care in me?' there is a large degree of agreement about their answers – whether yes or no.

The key point is that, whilst there was disagreement about the symbolic level, there was greater consensus about the feeling. (Maybe humanity is united at this deeper level.)

This means we could be faced with the curious situation of a picture of a mother and baby (symbol for 'care'), represented in a style which *does not evoke the feeling of care*!

When looking at images, therefore, it is essential to go beyond the surface representation and connect with the visual language.

The implication for designers lies in the realm of visual consistency. If a promise is held out to the reader by the quality of an image on the cover of a brochure, book or magazine, ensure that the same qualities continue to be delivered on the pages that follow.

The audience will pick up the mixed messages – albeit subconsciously. They will not think that the visual language is confused, but that the client/product/service is confused.

The designer, responsible to the client, serves best by by taking responsibility for the visual language.

In the real world, where the sources of images vary, it is useful to remember that the image is rarely used on its own and does not have to remain 'raw'. Once it is put into the context of grid, type, space, colour, etc, *the whole* will convey the required quality. The image is but one element of the visual language.

So when using a mixture of supplied and commissioned images, employ all the tools of design to bring the two into closer harmony. If the job involves working only with supplied pictures, which may be less than adequate, these tools become vital.

The designers and photographers chosen for the pages that follow have been selected because their work makes the point. Every country will have their equivalents. **But in every country the essential principle of how one looks and what one sees will be the same.**

section **Fundamentals of image**

the main design
disciplines

newspapers publishing editorial

This section sets out the basic ideas which underpin this book.

1. Design exists in the context of communication

2. A photographic image can be positioned on a 'spectrum' that runs from 'primarily informative' at one end to 'primarily evocative' at the other end.

3. There's no 'good' or 'bad' position on the spectrum. The type of image will be appropriate to the communication task and design discipline. Thus newspapers, publishing (books), editorial (magazines), advertising, retail, packaging, graphics, new media, generally tend to use images within a particular range on the spectrum.

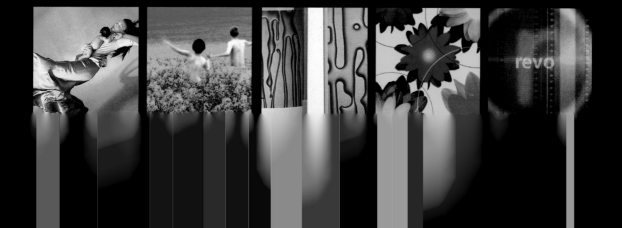

Image, tone, colour, type, shape, size, proportion, position, juxtaposition... these are some of the elements that make up the visual language.

The visual language is the 'tone of voice' of the message. As when in answer to: 'How are you?' we get back 'I'm okay,' spoken in a gloomy voice, we believe the tone and not the words, so too with the visual language – *people believe the tone!*

All communication takes place through language; not all languages use words. There's body language – conveyed through posture and gesture; there's the language of sound – conveyed through tone and rhythm; there's the language of image...

Design is an activity – the activity of communicating through the visual language.

The visual language, like the spoken or written language, has its cadences, rhythm and tone, syntax, vocabulary, phrases, sentences, chapters and forms – we get visual poetry, visual fiction, visual essays, visual documentaries. Sometimes it can send us into a dream or send us to sleep; disorient the mind or wake it up.

Its special power is to address the emotional centre. People can look at pictures with an open mind and read all sorts of meanings into it – at this cerebral level, interpretations might vary. But, once the heart is open, and the 'feel' of the image gets through, the level of disagreement drops.

Photographs are just one element of the visual language. Illustration, graphic marks and typography play a similar role.

So when a designer is making a choice regarding the look and feel of a page, photography is in the balance against illustration, graphics and type. It is not an either-or choice. All four could feature, a balance may be struck, but there is likely to be a dominant player.

A walk down the street of any city will show the extent to which modern life is dominated by images. If that city is in the Western world, then it will be easy to conclude that the photograph has won the battle for dominance.

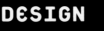

DESIGN　　　**PHOTOGRAPHY**

Every image represents a fine balancing act – a balance of content or information against style or evocation. The former addresses the intellect, while the latter speaks to the heart.

The visual spectrum will span a range that, at one end, has images in which the conveying of information is primary and, at the other end, the evocation of emotion dominates.

Every image communicates *both* – information and emotion. The difference is that in some the balance tips towards information – like the simple pack shot – and in others evocation dominates – like the 'art' shot. *In between lie the majority.*

As one moves towards the 'evocation' end of the spectrum there tends to be more intervention from the photographer in terms of 'effects' achieved through colour saturation, blurs, soft focus, texturing, layering, distortion, digital manipulation, etc. Here the boundary between photography and illustration becomes less distinct.

Effects do not necessarily increase the picture's power to evoke an emotional response. Some heavily-manipulated images can be totally devoid of emotion. Some classic images drip with evocative power.

'Reading' an image, then, can be seen as the activity of identifying its position on the spectrum. One must then assess whether that position is consistent with the needs of the brief.

There is no right or wrong position on the spectrum. What sort of image is used will depend on the requirements of the brief.

Different design disciplines will typically tend to use images from different areas of the spectrum. The Picture Editor on a newspaper, for example, will be looking for the pictures that primarily give the viewer information. This would position the image at the information end of the spectrum. A theatre poster or 'style' designer will take more license with content and look for pictures that are emotionally evocative. *In between lie the majority.*

Each of the various design disciplines themselves include examples of work which can be positioned at different ends of the spectrum. A new music magazine, for example, is likely to lie at the opposite end of the spectrum to an antiques magazine. A classical music magazine might not.

This book will focus on the broad area of graphic design.

Excitement, calm, shock, astonishment, awe, happiness, love, gentleness, security, confidence and peace are some of the emotions that could be evoked. Sometimes it might need to be a combination of two or three – that's when the designer and photographer have their work cut out...

The next 6 pages show images progressing from one end of the spectrum to the other. It is an exercise in reading a picture.

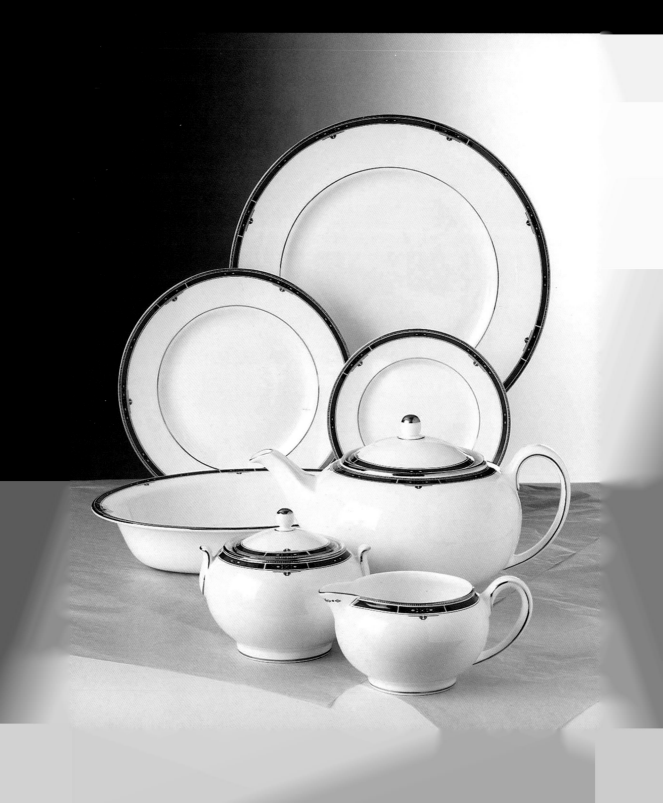

Here, not only do we see the crockery, but we have been given a lot more by the photographer. we know, for example that it is not pitched at grandparents the mood is wrong. what is it saying on the emotional level...? certainly more than the previous two.

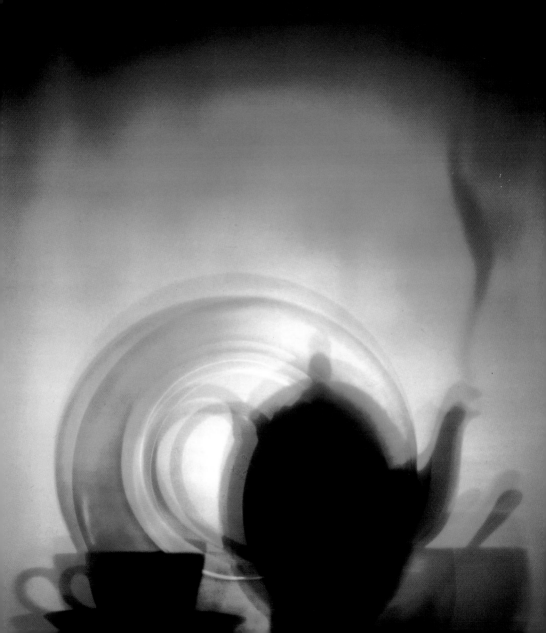

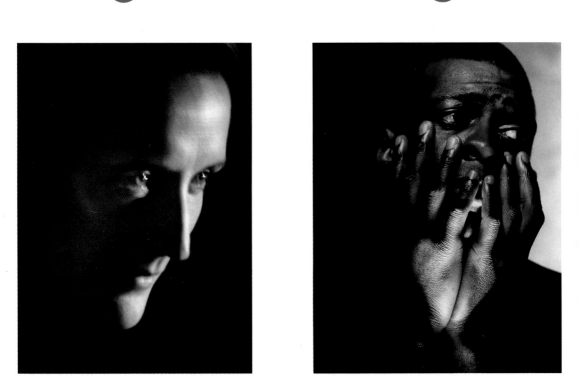

There are 10 positions on the spectrum where will you place A, B, C, D?
There is nothing obvious about the position - you might feel that some
images would occupy the same square - It's down to what you see.
Try the exercise by isolating the images one at a time Does your judgement change?

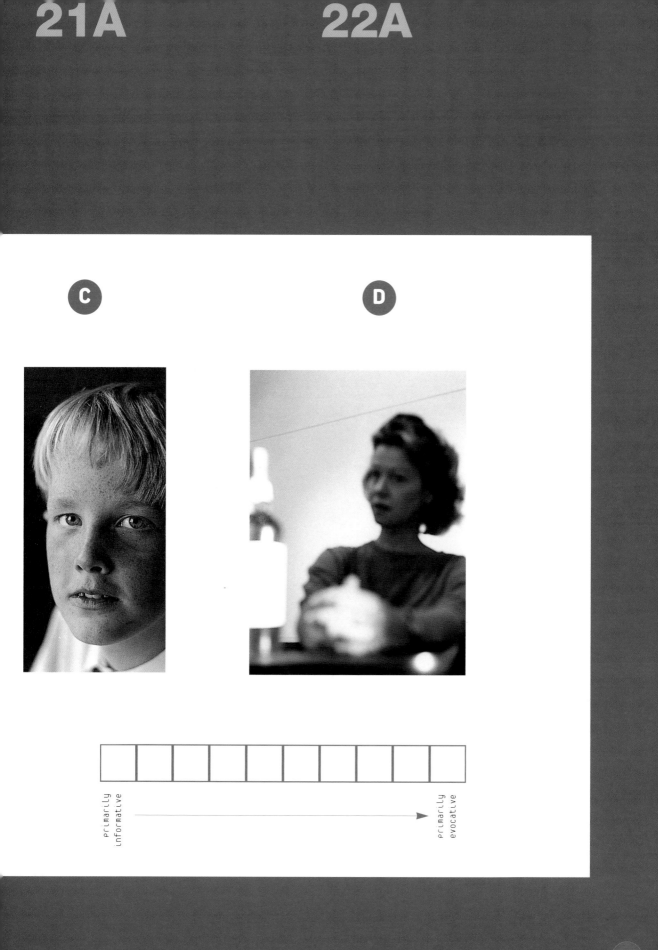

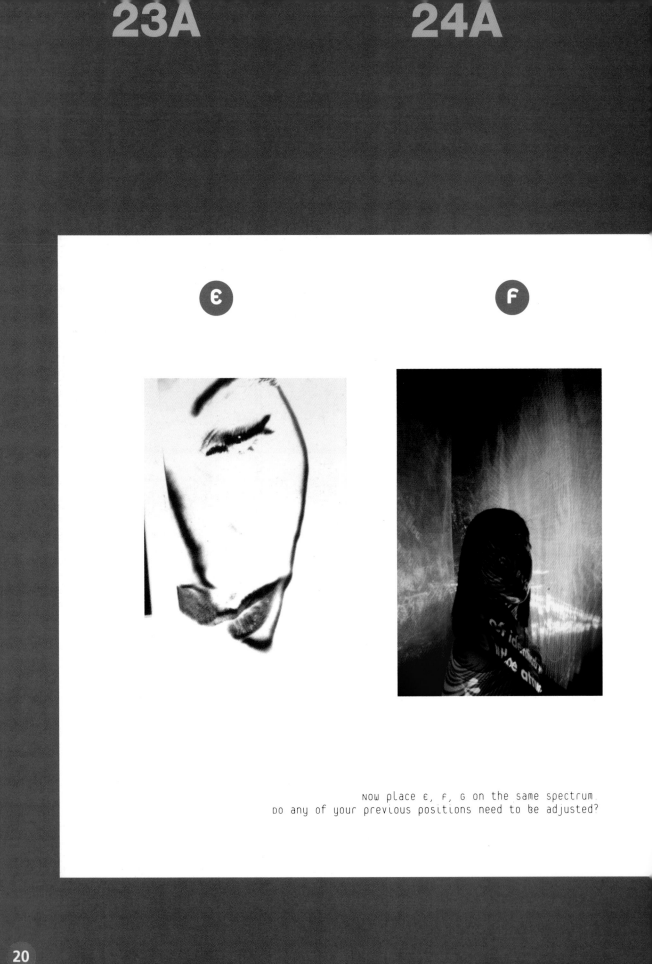

now place E, F, G on the same spectrum.
Do any of your previous positions need to be adjusted?

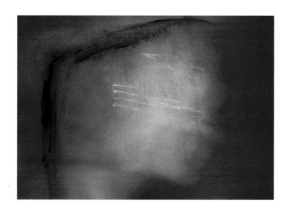

>

ON THE PAGES THAT FOLLOW WE SHOW HOW PHOTOGRAPHY HAS BEEN USED BY THE MAIN DESIGN DISCIPLINES.

IN THE BROADEST POSSIBLE TERMS, THESE DISCIPLINES WOULD TYPICALLY CHOOSE IMAGERY FROM DIFFERENT AREAS OF THE SPECTRUM - AND STAY WITHIN A FAIRLY NARROW BAND.

THUS, NEWSPAPERS AND PUBLISHING WILL TEND TOWARDS THE 'INFORMATION' END OF THE SPECTRUM, WHILE CORPORATE GRAPHICS AND NEW MEDIA CHOOSE FROM THE 'EVOCATIVE' END.

OF COURSE, THERE ARE EXCEPTIONS TO EVERY GENERALISATION...

General requirement from images
Information: High. **Evocation:** Low; sometimes higher on feature pages.

When I took over as Picture Editor at the Guardian, the use of colour was just coming into the newspaper world. I struggled against it, preferring black and white, and lost. I had to learn how to use colour, how to put colour features next to black and white ads, and vice versa. Colour can be garish, so it's my job to pace its use.

Despite new technology, The Guardian pages are made up in the traditional way, which is by the sub-editor in charge of that section of the paper. They all pull in different ways. There is no overall art direction. This creates problems, but it also creates a sense of visual urgency. When a newspaper is very art-directed it feels cold. This is fine for features, but not for news.

The deadlines make your adrenaline rush just thinking about them. Each day the newspaper begins as a blank sheet. And it must be filled by midnight. New technology is obviously a godsend in this area. But it also means that the Picture Editor can view 1,200 pictures a day, coming up on screen from press agencies and freelancers. Eighty percent of the Picture Editor's choices are made on screen. I'm not a picture editor any more, I'm an image-grabber.

News photographers no longer exist on newspapers. The six staff photographers in our London office will be used for subjects such as Health and Education – service pictures. News stories are immediate. By the time a paper had sent someone out to cover a story, it would all be over. So the news photographers are with the agencies and not the papers. 'Press photography' is a name which is going to have to change if we want to convey non-urgency. 'Feature photography' perhaps. News photographers have been replaced by picture researchers.

22

The typical day of a Picture Editor? – You make your choices, go and have a pint and then go home.

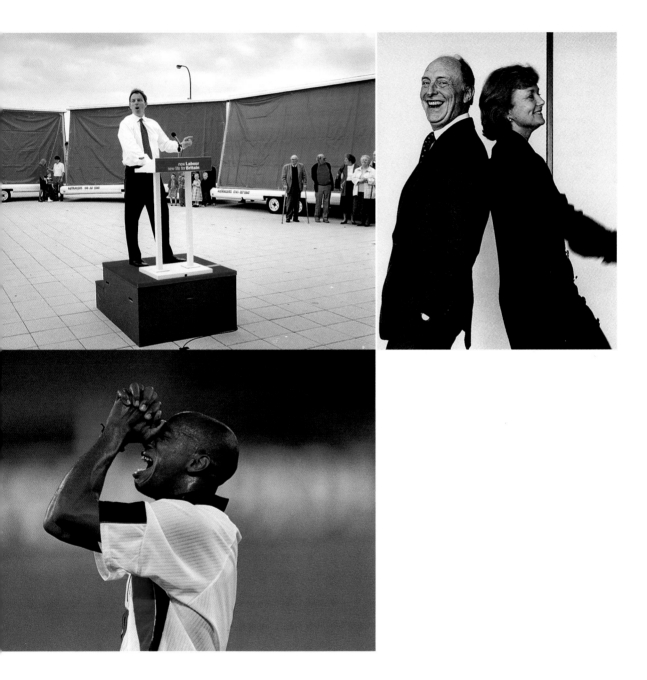

General requirement from images
Information: High. **Evocation:** Low on education books; higher on fiction covers

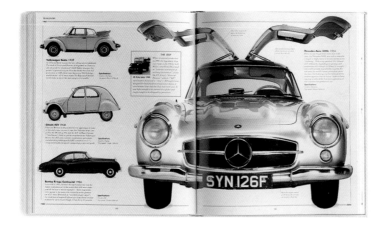

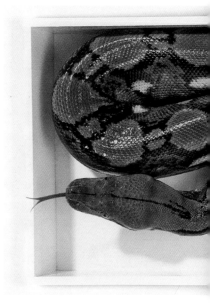

ISBN 0 86318 318 2

ISBN 0 86318 410 3

ISBN 0 86318 647 5

ISBN 0 86318 319 0

ISBN 0 86318 409 X

ISBN 0 86318 791 9

ISBN 0 86318 317 4

ISBN 0 86318 411 1

ISBN 0 86318 790 0

We have established a style with which we are now indissolubly associated: a photographic style so innovative, and a formula so successful, that it allows us to publish a new book on every subject under the sun, from sex to pickling, from spying to first aid. The cut-out photograph on a white background IS Dorling Kindersley.

On their own, pictures are too fast and words too slow, therefore our eye does not linger too long on photographs, and lingers too long on text. The right mixture of words and pictures speeds up the former and slows down the latter.

Each spread in one of our books has one dominant image called an icon. It must be clear, beautiful and informative. Cut-outs allow a close connection of words

A photo does the job best of all. It is real life. If the picture is real it has a quality which you cannot fabricate.

The reticulated python is a giant among serpents, sometimes growing to over seven of powerful muscle. The enormous bulk of an adult reticulated python, which can reach a weight of nearly 150kg, exerts such an overwhelming force when it is squeezing and constricting all life from it, yet barely breaking a bone.

to picture. The captions slow the picture; the picture speeds up the caption.

Some say the books are too illustrative and insufficiently authoritative, but the right picture with the right words simply means that fewer words are required.

Everything is taken on a white background, even elephants and planes. Cut-outs are not done on the Mac but at the repro house, where the results are better. We do not cut out the object at its edge, but leave a white margin which becomes invisible on the page. This keeps details such as fur and whiskers, where crude cutting-out would lose them.

The creative team will work on a book for anything up to 9 to 12 months - just one book at a time. Ideas are worked out in advance and then shot.

The photographer must respond to the need. If we are taking pictures of animals giving birth, and our subject chooses to start in the middle of the night, the photographer will get a call and he will be there.

The ideal DK photographer is one who who is interested in the subject – the behaviour of frogs or whatever. This is more important than techniques of composition and lighting.

Our business is Truth. We do not use tricks, either in photography or in design. We want people to look at our pictures and believe in them, because what they see is how it is.

Inner tepal
(monocotyledonous
petal)

Groove
secreting
nectar

Filament

Outer tepal
(monocotyledonous
sepal)

General requirement from images
Information: High. **Evocation:** Typically low but getting very high in lifestyle publications

I worked on 13 issues of *Colors* and then left. I now run a tiny design consultancy in New York.

I like to use photographs provocatively to shift perceptions. Benetton gave me a complete freedom to design *Colors*: it reflects my style, not theirs. In these days of aggressive media it is important to be aggressive with photography, to give it an overtone. Benetton used my style to achieve a hip association with their products. They wanted to create a blur between the image of the product (unhip) and the image (hip) in order to drag the product up.

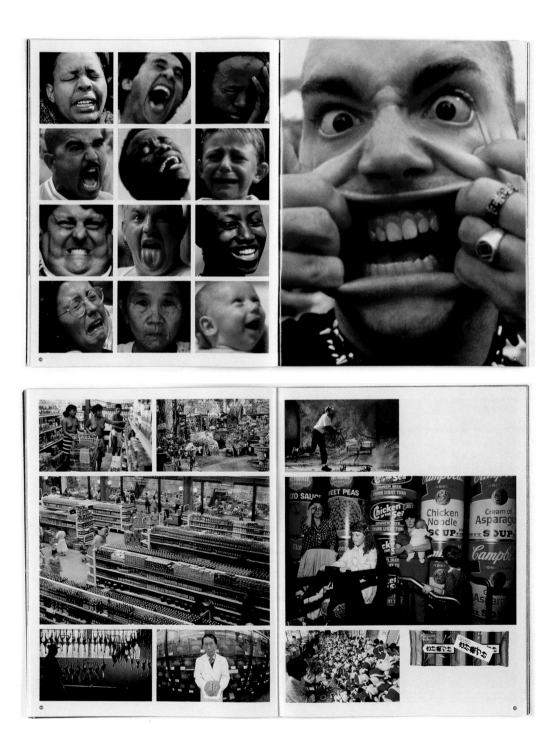

General requirement from images
Information: Concept led. **Evocation:** High enough to attract without overshadowing concept.

Photographs are used differently in ads from the way they're used in design because designers of brochures and literature generally have a captive audience. Ads have to work harder. They need to grab the attention. They are about increasing sales – something measurable – and so the briefs are tighter.

Advertising images are characterised by high production values. You want your stuff to look expensive. You want to show the product in a way that people would aspire to. That's what the client wants. Sometimes this means using photographers that are big names to flatter the client. Less experienced Art Directors go down this route and can sometimes run into trouble art-directing a diva.

A good Art Director has the image clearly in mind, and can produce great results working with any good photographer. It's a collaborative effort, each bringing something different to the party. The key is to know what you want in the first place and then not be too rigid. This leaves the photographer free to make their input.

The grandees of the old days might shudder at what's happening now – Art Directors having to come to terms with computers! Everyone gets their hands a bit more dirty these days – even some photographers now have Macs and supply us with retouched images.

We're always on the lookout for something different and will use whoever we can to achieve that. We don't divide photographers into editorial, design, advertising, fashion. On one Silk Cut campaign, for example, we used photographers whose reputation was built on soft, muted portraits. They needed persuading that they were the right choice for the idea. The ads have since appeared on several awards lists. So we're happy to push further.

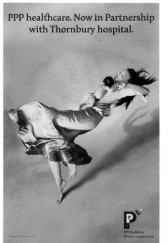

PPP healthcare. Now in Partnership with Thornbury hospital.

SMOKING CAUSES HEART DISEASE
Chief Medical Officers' Warning
5 mg Tar 0.5 mg Nicotine

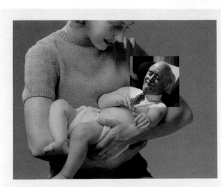

The new Club World cradle seat.
Lullaby not included.

BRITISH AIRWAYS
The world's favourite airline

A FUTILE ATTEMPT TO BE HAPPENING MADE BY ONE DOG.

A NATURALLY FERMENTED ALCOHOLIC LEMON BREW MADE BY TWO DOGS.

The 'classic' ads of the 70s and 80s have given way to a greater variety of styles as society gets more fragmented.

SMOKING KILLS
Chief Medical Officers' Warning
5mg Tar 0.5mg Nicotine

Wash away jet lag.
The Club World arrivals lounge.

BRITISH AIRWAYS
The world's favourite airline

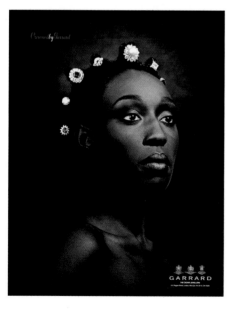

The agency Art-Buyer sees as much work as possible and feeds the Art Directors with new influences. At the end of the day, the Art Director needs to meet the photographer to get a feel for what makes them tick. They both need to get on. It's a relationship. That's how great ads are made.

Retail: Body Shop
Jon Turner, Head of Global Design

General requirement from images
Information: Medium to low. **Evocation:** High.

We work with many photographers, the key to successful working relationship being versatility and understanding. This may seem obvious but we are a franchised global company, so we need to request long worldwide agreements to ensure that we are covered legally in case a member of a franchisee's staff should inadvertently reproduce an image.

We use different photographers to suit specific briefs. We have a series of 'product', documentary, people or technical photographers who we employ freelance. We also use in-house skills. Documentary libraries form an important part of our photographic database.

Nearly all the pictures are specially commissioned. A typical brief will come to a photographer after our designers have visualised a concept and it has been through all the internal approval processes (legal, ethical, client and copy).

The photographer will contribute greatly with creative ideas if appropriate, but we can certainly be accused of just using some photographers to execute our concept (and in this case we use people who are happy to accept this).

When an image is to be digitally illustrated, collaged or designed, a photograph is only the basis for the final poster – which is usually the case with us.

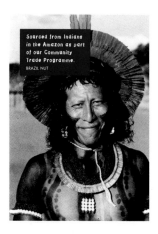

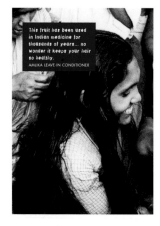

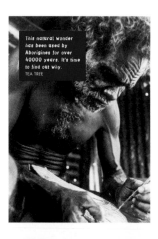

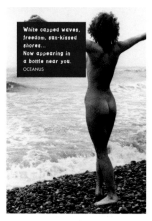

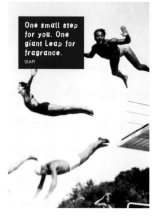

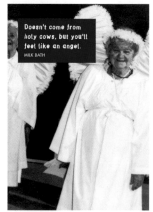

30

Projects are rarely planned in meticulous detail due to volume of work and speed of turnaround (we change window posters every two weeks in 46 countries and 26 languages and have approximately live 200 jobs within the studio).

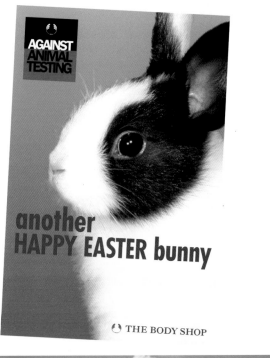

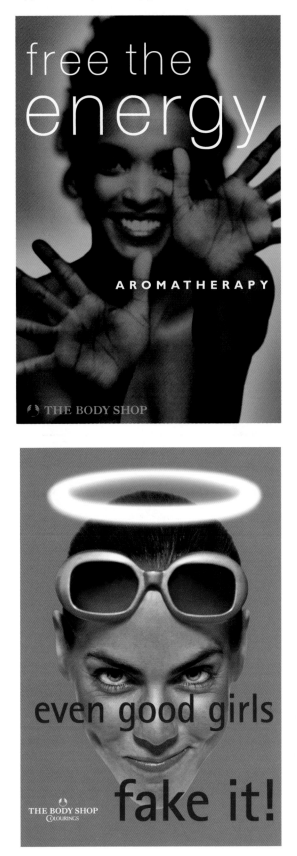

Packaging: Michael Nash Associates
Anthony Michael, Partner

General requirement from images
Information: High. **Evocation:** High enough to attract without distorting product.

This commission was part of a classic range of products to package food like a silk scarf. The package had to show feeling rather than to represent food. There are two to three categories in the range:

- Classic – textural (olive oil, baguette bags, etc).
- Common products approached in an unusual way.
- Location specific.

For the chocolate drink we asked, 'What does chocolate drink make you think of?' the answer was not cocoa beans but a naughty boy with chocolate around his mouth. We sourced a range of images for this, from libraries, friends, photographers – anyone who might have just such a boy in the family. We found him in the godson of the guy who runs the fifth floor of Harvey Nichols.

For the location pictures in the Italian range we wanted something festive for the panettone and came up with the pic of the street and the guy on the bicycle. The white triangles are Italian Christmas decorations. We did not want to use stereotypes of place or location but to evoke that soft, fond memory – not nostalgia exactly, more that obtuse image which brings a place to mind. Again we went to many sources – picture libraries, books; finally we found a photographer who enjoys Italy and shoots pictures there for pleasure.

The next range is to be American – salad dressings – and we'll use surfers and beach scenes, but we'll keep to black and white in duotone. This is the right tone for Harvey Nichols, for it uses the language of fashion rather than food.

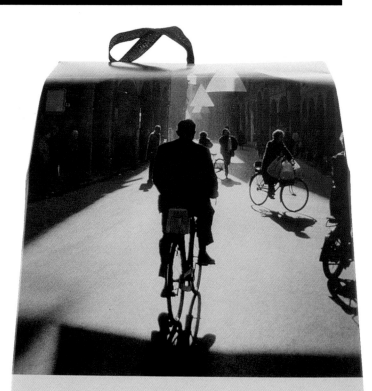

For the Harvey Nichols project we worked closely with the store. The Harvey Nichols' people had strong opinions, but were willing to brainstorm and play, rather the sit back and be judgmental.

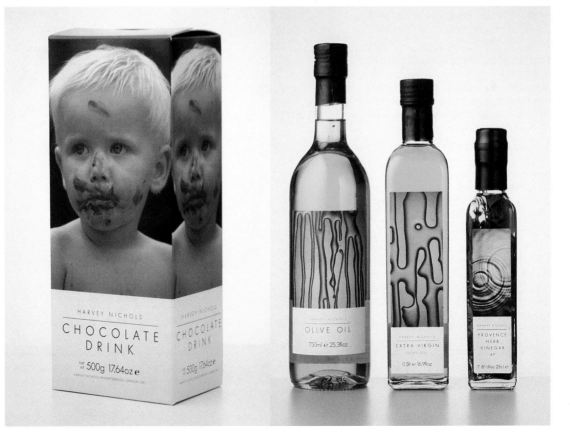

Corporate Communication: Quadrant Design Associates
Peter Bonnici, Creative Director

Ten years ago, the majority of our projects involved illustration because illustrators, working more like artists, seemed to have the ability to get under the surface of things whilst the work of photographers at the time – despite other strengths – had a sort of 'hard' veneer about it. All this has changed.

Photographers suddenly started to produce work in which the subjects being photographed were not ends in themselves, but merely the starting-point for imagery which addressed the emotions. Photographers have become the new abstract artists, conveying excitement and mystery. They make you look again. This is the baseline for communication.

In our design we expect the images to work quite hard. As words and pictures in a comic book both work together, each assigned a different role, so do they too in our designs. The pictures convey the emotional messages and the text carries the cerebral ones.

That's why we feel it essential to work with photographers as partners We start by understanding their strengths and aspirations and then let them get on with it. Our brief takes the form of a discussion about what the client is aiming to express and the qualities we're trying to project.

It's always interesting seeing the personal work of photographers as well as their commissioned work. If the commissioned pictures lack a certain vitality, then we know that the photographer's personal sensibility is what makes their work great and use them on the more open projects.

The client we like to work with is one that stretches and excites us. The type of photographer we love to work with will force us to reconsider our clichés. And, hopefully, we do the same for them.

New Media (interactive kiosks, web, cds): Dogs
David Fennel, Director

General requirement from images
Information: Varies by project. **Evocation:** High.

The presentation of photographic material is constantly gaining in quality as the speed of digital technology increases and the cost of hardware falls. Different delivery media display different strengths and weaknesses. The common factor, however, is the monitor on which we view all screen-based media.

Compared to print, computer screens have a very low resolution – dots on screen are at least four times the size of dots on the printed page. Where pictorial information is required, one considers far more carefully the purpose of the image and the size the picture must be presented in order to convey the information required. In the case of a car, the user can discern the make, model and colour from an extremely small picture, but if the fabric quality of an interior shot is key then, obviously, the image must be displayed with many more dots, i.e., larger.

Image-manipulation software has freed designers from the traditional separation of text and image and allowed the complexity and layering displayed by the cutting-edge practitioners. Given the coarse resolution of the computer monitor, the possibility of layering information is most attractive – particularly in interface design – for utilising the limited space more efficiently and creating richer experiences. Here, even more than in print, the high degree of image control is vital in the fine balancing of the 'voice' of a picture so that it communicates at exactly the right volume, neither shouting too loud nor drowning in the cacophony of the page.

Authoring screen-based media, if it is to be well designed, is time-consuming and labour intensive process, but given time, with the digital imaging tools available, absolutely anything is possible.

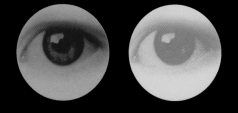

section 2 Designing through the lens

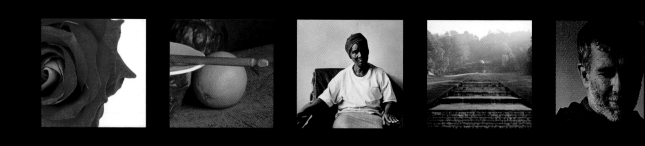

This section looks at what the photographer brings to the project before his or her image is put into the context of type, space and colour by the designer. In it we showcase the work of 10 photographers to illustrate the main theme of the book, which is that every image is a balance of information and evocation – it is simply a matter of what side of the balance it leans towards.

The work on the next few pages broadly covers that spectrum, although it would be misleading to give the impression that the steps are clearly divided or that the photographers profiled do not work outside the range of the spectrum suggested by the sequence of pages.

The work of the first eight photographers is primarily created in the camera, the ninth is heavily processed through the computer screen. And, just to show that every theory has its exceptions, we end with the work of Sebastiao Salgado, whose untampered images drip with evocation.

Photographer: White Backgrounds

Simon Farnhell and Jennie Mackay.

Work: Niche player: pack shots, flat copies – everything photographed on a white background.

We were both trained as photographers and decided to offer a service which involved photography because we love photography. We specialise in pack shots – others tend to tag it on as an afterthought.

Both of us have our own outlets for the more expressive side of our work – I spend my free time creating digitally-manipulated photo illustrations for libraries and Jennie does portrait work. But even with the simple pack shot there is an element of creativity – it needs to look good. Even a shot required for a critical magazine article still needs to look good.

Then there's the technical side of things. We tend to use a film stock which is saturated and that makes the objects look slightly more exciting, more punchy. But if colour accuracy is required, we use a different film. Part of our skill is to know the tolerances of the variety of films on offer – some, for instance, don't respond to green, they turn them bluish. We need to know that, especially when having to stick absolutely to a corporate colour.

Problem-solving, too, is what we enjoy. It's a disaster if you shoot some of the modern lipsticks in their polished chrome cylinders only to see a reflection of the photographer desperately trying to hide under black cloth. We could spend hours setting up a light tent to overcome this problem, but if it's editorial work (not renowned for big budgets) nobody wants to pay half a day for one shot. Lord preserve us from round shiny things!

We work in a variety of ways – sometimes we're left to get on with it, sometimes we are given a detailed rough, sometimes the Art Director attends the shoot. At the end of the day, they are coming to us, not for our own personal vision, but to represent their products clearly.

Work: Started in advertising, but now works mainly in publishing. Specialises in food, flowers, crafts.

My expertise lies in still life and step-by-step photography required by specialised books.

By demand, I specialise in cookery and flower-arranging books, and now crafts. I'd describe my style as chiaroscuro – diffused light and heavy shadows. My daylight is imitation. My style is 'lived-in'.

As a photographer there is an apparent difference between advertising and publishing. Advertising work has to be chased. It is a highly competitive world. It is stressful, although sometimes the stress is useful, in terms of stretching you. There is a great difference in attitude between the two worlds; people are forever being pushed. Having come from advertising, I bring an advertising attitude to editorial projects.

In business at the moment a lot of design groups that came in 8 to 10 years ago tend to be middle of the road, doing pedestrian work. There is a gap between them and the ad agency level. They tend to look after product sales while the agencies create the image for the brand.

In publishing, I normally work with editors, designers, stylists, home economists and sometimes the author. Often the stylist will suggest the colour and mood. Some publishers give me their brief and leave me to get on with it.

In the past you might have spent 3-4 days searching for the perfect location, and then getting up at 5am for the perfect light. Today so much is done on computers that the craft aspect is being lost – and so is the glamour. Car photographers are having a particularly hard time. Once they would go off to glamourous locations like Corsica; now they go to the studio.

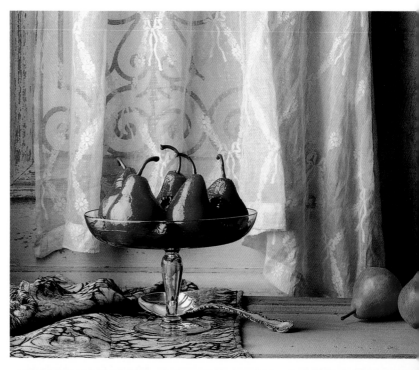

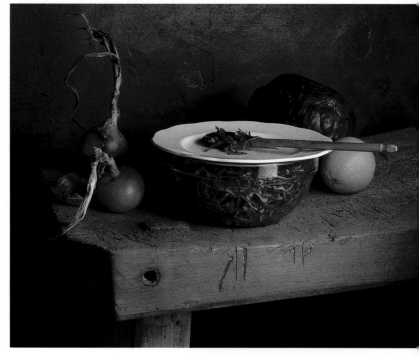

What the photographer can bring to the job is composition, colour, texture, inspiration.

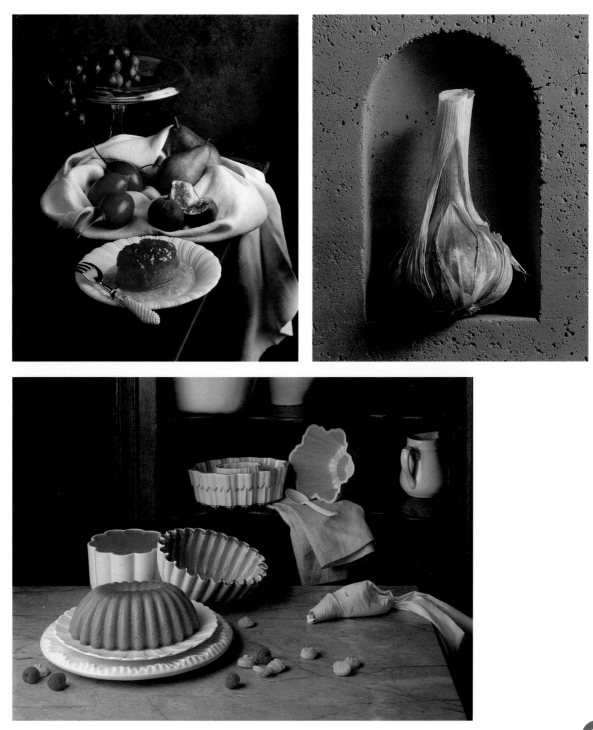

Photographer: Jillian Edelstein/Network
Started in South Africa in photo-journalism, now also works in portraiture and advertising.

Work: Mainly editorial and corporate, with some advertising. In this section Jillian has focused on a photo-story for the 'Truth and Reconciliation Commission' in South Africa. The essay has been published around the world and won the **Visa D'Or** magazine feature of the year in 1997.

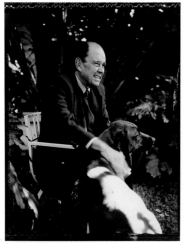

1

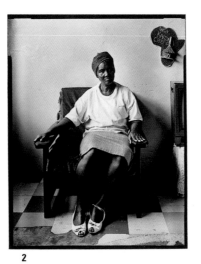

2

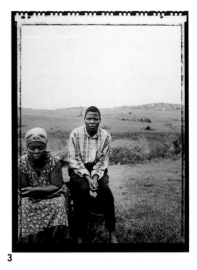

3

4

1 MAGNUS MALAN, FORMER MINISTER OF DEFENCE. ACQUITTED AFTER TRIAL LINKING HIM TO MASSACRE.

2 ELIZABETH HA SHE, ONE OF THREE WIDOWS. HUSBAND DISAPPEARED, INTERROGATED, TORTURED AND KILLED.

3 KWAZULU NATAL. PEOPLE WHO LOST RELATIVES WHEN ZULU/INKHATA IMPIS OPENED FIRE DURING A PARTY.

4 FATHER LAPSLEY. RECEIVED LETTER BOMB IN 1991.

5 JOYCE MTIMKULU HOLDING HER SON'S HAIR WHICH FELL FROM HIS HEAD DUE TO POISONING BY SECURITY FORCES.

I try in my work – which I'm happy to say varies widely these days – to pursue a visual honesty, a visual surprise, a visual realism that encompasses the new and the old, because societies evolve. I love the idea of using new technology discretely.

The idea of sameness or formula is my worst nightmare. The memory of two incidents still sends a shiver down my spine. The first was when an Art Director, after viewing my work for an assignment, exclaimed: 'Gosh, Jillian, talk about breaking the boundaries of portraiture.' For ages the comment rang in my ears every time I lifted the camera. The second incident was the comment of another: 'Your trouble is that you're inconsistent – one never knows what one will get. It's too much of a surprise.' Those were in the bad old days.

Ten years after I first started, I am more free to shift between disciplines – between 'press' and 'portrait' – without being dismissed or labelled. It's as if I have done my time. I no longer feel that to get noticed I need a 'recognisable' style. It frees me to be spontaneous, passionate, to follow the instinct, to allow the mood, light and interaction with whoever or whatever to set the visual tone or landscape.

It's hard during the 'picture-taking event' not to be affected by the comments of the designers. My favourites are those with whom there exists a relationship of mutual trust and respect – they understand what I can bring to the project and let me get on with it; and I, on the other hand, trust them to do what they do best. The outcome is always good.

It's equally hard not to be affected by the sensibilities of the sitters and the visual literacy of the viewers. In the final analysis, the wonderful thing about the complexity of humanity is that the subconscious, the instinctive, and the natural 'right' creative 'thing' emerges.

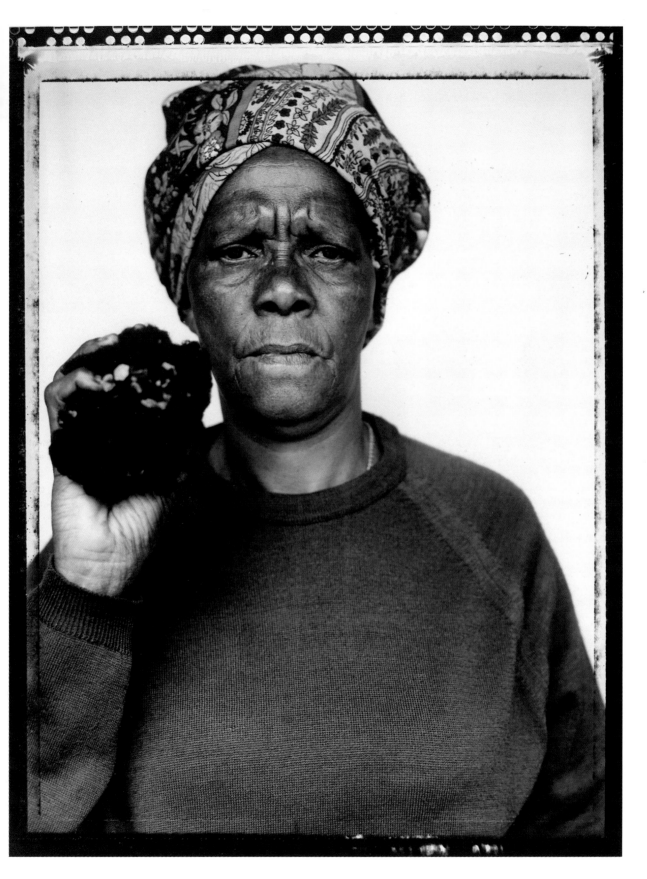

Work: Editorial and Publishing. Specialises in landscape gardens, stately homes. Also books on behind the scene at the Royal Opera House and life in Covent Garden Market, London.

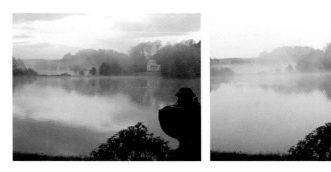

I consider myself very lucky. I have shot some of the most beautiful gardens you can ever hope to see. Yet when I walk into a new setting I genuinely forget the other gardens I've been in. When I see a lake or bush or path or box hedge I never compare it with any other place – my favourite garden is the one I'm in. You photograph the landscape like you've never seen it before.

I'm not a smash and grab person, I like to work a picture through, stick with it. Sometimes you may think that you've got the picture, then half a minute later the light changes and there's a pink you hadn't noticed and, gosh, look at the mist on the lawn and then the light will change and change again.

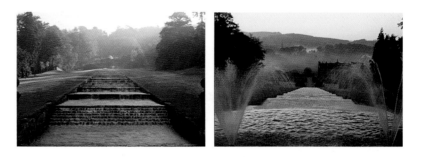

You just have to be obedient to the light. Sometimes I think of myself as a sun-worshiper, obeying every tiny movement it makes across the sky. The light in the morning is soft and cool and then as the day moves on, the colours start getting more intense till the sun is high and there are colours all around. Then evening light... soft, bringing things to rest.

Do I impose myself upon the image? I carry technical expertise about what's going to work in a particular garden. You know instinctively what's going to happen with the light. I know what I'm going to do with the setting, I see what there is to have. Rarely I might use a filter, just so that the range of tones is reduced so that I am not forced into making a choice between getting the detail in the sky or getting the detail of a stone wall under the bush. The eye can do it, but the tonal range of film is crude by comparison.

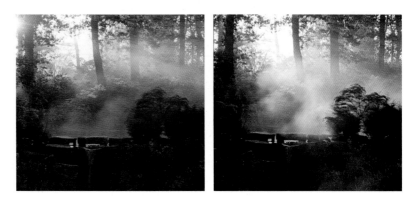

each of these pairs of pictures were taken within minutes of one another – it's worth sticking around for the light to change. In the middle pair, the view is from opposite ends of the cascade – it's worth trying something new.

There's part of me that believes that if a picture does not have a similar effect on the viewer as it has on me, then it has failed.

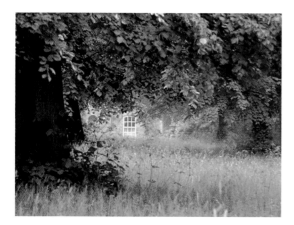
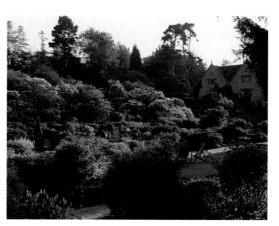

Look at each of these pictures in isolation. They have been taken at different times of day. Can you tell from the quality of light? If so, how can you tell?

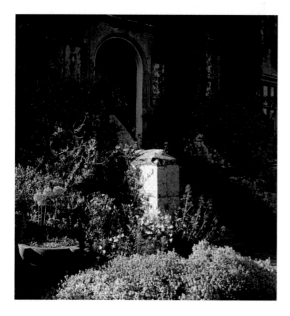
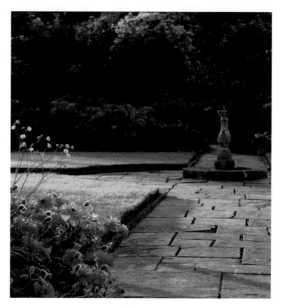

Photographer: James Hunkin

Work: Publishing, editorial and corporate. Specialising in portraits. Published two books: 'Changing Faces', portraits of National Theatre actors, directors and writers; and 'Faces of Faith', portraits of faith community leaders in the United Kingdom. Work shown at the Royal Academy, London.

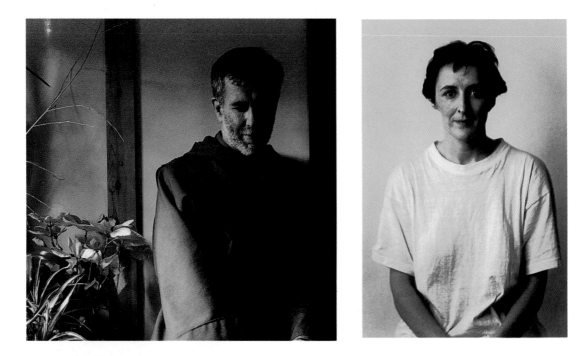

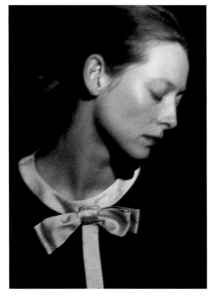

When I prepare for a sitting, I generally try and keep my mind free form any prejudice or preconception, however difficult that may be. Half of me tries to engage with the open, emotional and communicative nature of the individual, while the other half operates with the surgeon's scalpel. It is the way I work as an expression of my nature.

All portraits are records of a meeting between two people with just one face recorded. The relationship between the photographer and the subject is what is revealed. I am interested in mutual collaboration, and would regard those portraits as failures which either raised the portrait to an icon, or simply recorded the physical likeness of the subject.

The contact sheet (hopefully!) provides me with a memory of the time spent with the subject, and I choose the shot that seems to be the most comprehensive and true to that memory, emotionally and intellectually.

I dream of being given the time usually allowed to a portrait painter, but at the same time I am aware of the potential advantages of working at speed. If I know I only have a short time with someone, I am very concentrated and hyper-sensitive to my instinctive response to the subject (while trying to appear relaxed, confident, competent...!). This strong sense memory helps me to re-live the experience of being with the subject, when it comes to printing the chosen negative.

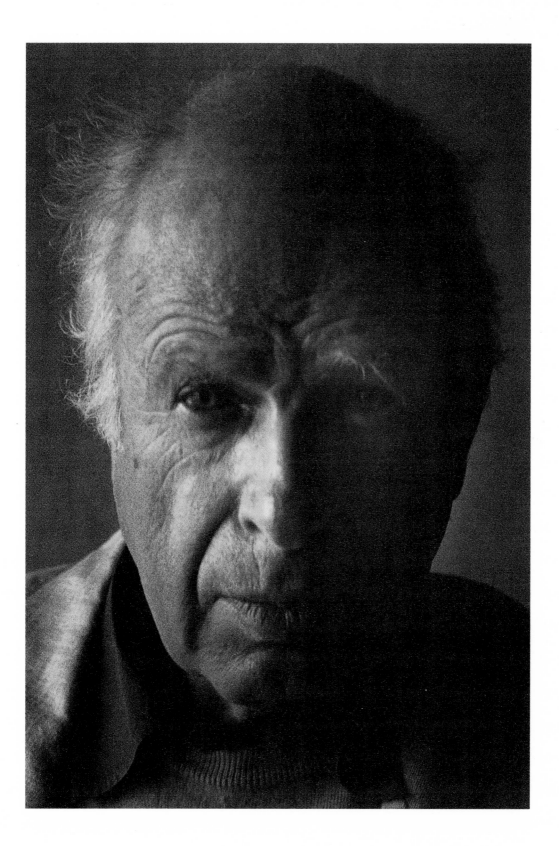

Photographer: David Scheinmann
Multi-disciplines, in various media.

Work: Fashion, design, music, advertising. Recent work includes television documentary, music video, and TV ad. Current passion – writing. Various personal photography projects.

During my twelve years as a commercial photographer I have been part of a trend which is gradually changing the way we are perceived by the industry and consequently the way we are commissioned. I no longer feel the need to apologise for operating in several photographic genres to an industry that classified us and divided us by subject – food, cars, landscapes, people, etc. It was, in fact, photographing people that led me to my multi-disciplined approach, since people eat food, drive cars and situate themselves in landscapes.

The enlightened Art Director will commission a photographer (or any commercial artist) for their general approach, their sensibility, their unique style. They have to understand what the photographer is about. The style of an image can tell us an awful lot about the cultural position and sensibility of the author. Reading an image requires a highly developed visual literacy on the part of the commissioner and the photographer himself.

Commissioning photographers on the basis of their familiarity with a subject or their cosmetic execution of 'a look' is no longer enough. This generation of creatives live in an age beyond post modernism. The rapid assimilation of images and their cosmetic looks or surface styles or specific effects in an era of computer post-production means that now, more than ever before, we need to transcend this surface.

Paradoxically, the most influential part of an image is also the hardest to see – it is made up from invisible impulses that drive the choices the photographer makes in creating the image. The more control on style, the more we control the communication. This is the process by which we elicit the desired response from the viewer.

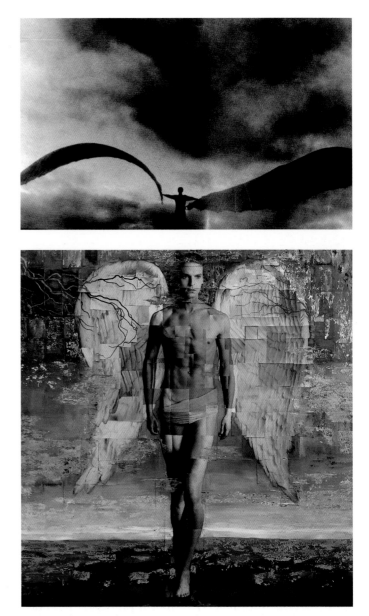

The target audience is less impressed by the hollow pyrotechnics of the image. If we are able to elicit an emotional response through communication that has integrity, style and passion, then we connect with them.

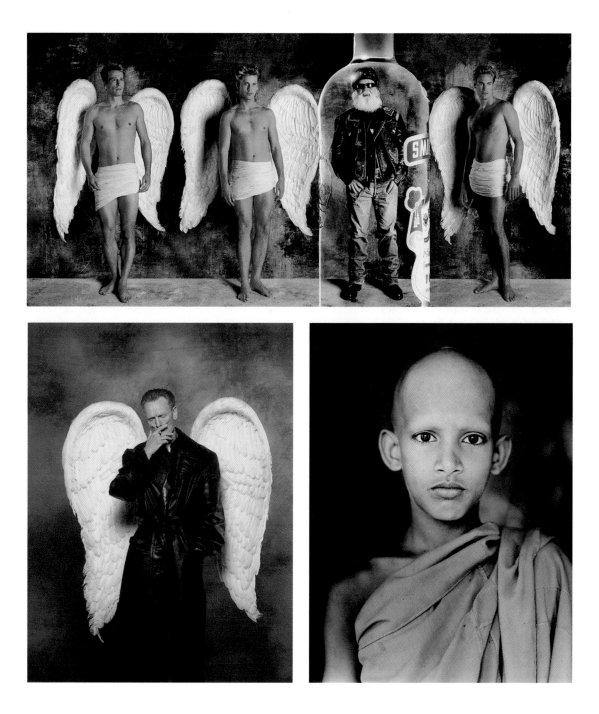

Photographer: Carol Fulton
Freelance since 1990.

Work: Ranges from book covers, posters for opera and theatre, corporate brochures, some editorial and private commissions. Has taught at Central St Martins, London, and exhibits work regularly.

The field of photography spans a vast range of approaches – from very objective to highly subjective; the very literal, descriptive and informative to the more abstract, suggestive and atmospheric. My work falls within the middle/upper end of the latter.

The notion of looking, thinking, behaving in layers interests me, and is a recurring theme in my images; the eye passes through mist, veils, snow, flowers – to reach the figure. In this respect the idea of text over image becomes a very attractive one – in one sense by continuing the idea of layering (the text 'floating' on the surface, thereby adding illusion of depth); and further, by providing a contrast, the sharpness and opacity of type acts in healthy opposition to the softness of the image – bone and flesh – type frequently enhancing a piece of work, acting as some kind of hinge/hook from which to hang the image.

When the two work together, both photographer and designer have a responsibility to one another, a mutual respect, and a sense of trust/faith (trust in the other's integrity and faith in their talent!). A more exciting result is achieved when two craftspeople collaborate. If both aspects are created in isolation, one loses out on possibilities that arise from the sharing of ideas and styles – the potential that something totally unexpected may result – and often a certain dullness and lacklustre quality pervades.

The two elements – photography and design – can be seen as equal partners in a potentially exciting collaboration, a fusion from which may spring a kind of magic...

Photographer: Barbara and Zafer Baran
Abstract photography.

Work: Corporate design, music, theatre, editorial commissions. Several exhibitions of personal work.

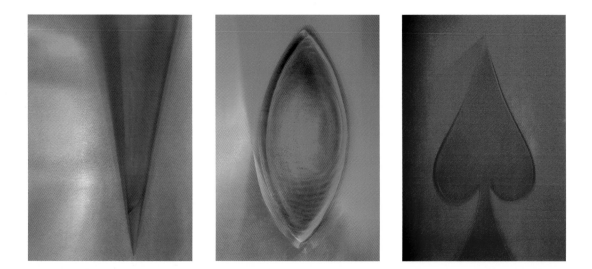

We first met in 1981, studying photography at Goldsmiths' College, London. Since then we have been working together, initially on personal projects and exhibitions, and since the mid 80s also on commissions.

Whilst the commissioned work tends towards the abstract side, our personal work covers a much broader spectrum, from black and white documentary and landscape photography to portraiture and the conceptual image. We each have our own interests within these areas, but often collaborate where the subject suits us both.

Our commissions generally come from design groups, and encompass both the arts and corporate sector. Particularly in this latter area, the designer's interest in our visual language has to combine with the client company's willingness to depart from the conservative approach, and to eschew the symbols and figurative messages common to this sector. Instead, the brief will call for a totally abstract interpretation, suggesting rather than directly illustrating the underlying idea. (This may, for example, be an evocation of speed, vigour or dynamism.) A specific mood will thus be created.

Typographical photography comprises yet another aspect of our work, stemming directly from Zafer's background in graphic design. But then, there are so many areas in which our work has been applied, from the architectural (where it leans heavily towards the 'classical' side), to the moving image, where, in its sometimes most abstract form, it has been used to create film and television titles.

For us, it is important to be free to explore and improvise, not to be tied to any particular style or mannerism. The abstract work forms the more public side of our output; the private side necessarily remains multi-faceted.

Work - corporate design clients for blue chip corporations; editorial.
Winner of numerous awards for images.

WHEREAS THE WORK ON THE PREVIOUS PAGES WAS DONE MAINLY IN-CAMERA, HERE IS WORK THAT WAS NOT.

A theme throughout my career has been experimentation: painted emulsion, cross processing, selective focus, multiple exposure and in-camera or darkroom blending.

This non-traditional approach to photography has become the foundation of my creative process. The introduction of computers as a creative tool suited my vision of manipulating photography and has allowed me to develop my internationally-recognisable style.

The core of my point of view is storytelling – the ability to create a visual that has a concept or vision. A single straight photograph doesn't quite have the depth of a collection of photographs organised in a well thought-out design, intended to lead the viewer through a vision or a virtual environment – one that could not exist without computers.

The elements included in the final composition are photographs that I have taken for a specific idea, or from archives that have been built up over years. The library of 17,000 images are the building blocks of the concept. They are manipulated and combined to shift them from mundane objects to a highly-illustrative design.

My clients often give me carte blanche in the creation of the concepts. They usually give me a single theme to work with, like 'Medical', for example, and I go off and create pencil thumbnails of my ideas to best represent that theme. Once the concept has been approved, I swap the pencil for a scanner and computer and start to manifest the image in my mind's eye.

As the Art Director, Designer and Photographer of the artwork, I believe that computers can be an amazingly creative tool for artists. All great works of art, however, start with the mind and a pencil.

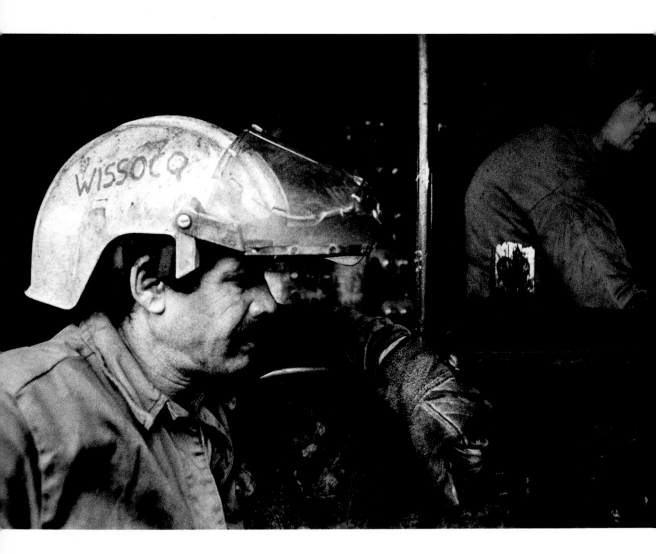

This brings us to the end of our spectrum of photographers. It was intended to take you on a journey of feelings – not necessarily in a straight line, but in a general direction. At each step of the journey, the photographer's footprints become more visible. With the pictures on this spread, we close the circle – we are back to 'straight' photography...

The form is a means to an end, content is all. Salgado is first and foremost a communicator, his pictures a call to action, to arms even. While we marvel at the power, the complexity, the humanity of his images, it is the issue that most concerns him. Through his work he has done what most photo-journalists dream of, he has helped bring about a change for the better.

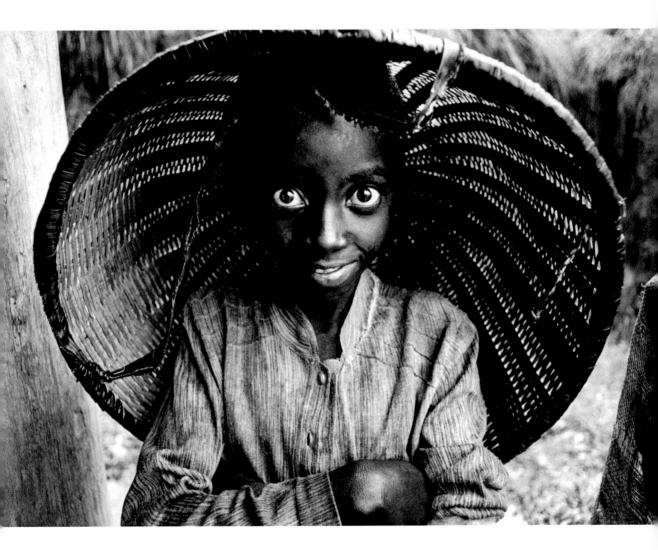

We shall not cease from exploration / And the end of all our exploring /
Will be to arrive where we started / And know the place for the first time.
T. S. Elliot, *Four Quartets.*

section

Getting the picture

Although no two jobs are the same, the broad steps of the design process are generic. In this section we look at the process from the designer's brief to getting the final image in your hands. It covers:

visual language

commissioning new photographs

the photographic shoot

the selection process

the pool of existing photographic images

doing it yourself

Uncovering the visual language...

Briefs come in all shapes and forms. The designer's first step is to get behind the client brief to uncover what lies at its heart. There are two aspects that need consideration: the information to be conveyed and the emotion to be elicited.

Both these aspects will determine whether photography is the right type of imagery – the alternative could be illustration or cartoon or typography, to name a few.

When the subject is a tangible product the decision to use photography is quite common, but even this is not a hard and fast rule. When the subject is primarily the mood you wish to create, other illustrative forms enter the frame.

The first key decisions then are related to the "look and feel", in other words, the visual language that projects the required values and elicits the desired emotional response from your audience.

This applies right across the design spectrum from CD cover to ads. What is this look and feel?

The quality of imagery is what will carry the emotional content of the message. The content will carry the information. A trap is to get form and content mixed up – they each have a distinct job to do.

Uncovering 3-4 core values...

The first step requires reducing the brief to a few essential qualities. Qualitative words are values such as integrity, innovation, intelligence, responsiveness, flexibility, security, trustworthiness, openness, etc.

The hard task is avoiding the clichés and reducing this list down to the three or four values *distinctive* to that client or product.

Although your list might well contain words that others could claim, the particular combination is what will be unique. An example of this would be that a word such as 'care' is a given for the health service. But 'care' combined with 'excellence' and 'sound-management' will evoke a different emotion than when 'care' is combined with 'integrity' and 'responsiveness'. The first will produce a sharper, harder visual language than the second.

The second step is to translate these values into their visual equivalent. What 'look and feel' will evoke, for example, care and integrity and responsiveness – all together?

HERE IS ONE PROCESS FOR GETTING FROM A SET OF VERBAL VALUES TO THEIR VISUAL EQUIVALENT.

- COVER A LARGE TABLE WITH RANDOM IMAGES, TORN OUT OF MAGAZINES, BOOKS, ETC.

- HOLDING YOUR THREE VALUE WORDS IN MIND, START TO REMOVE THOSE IMAGES WHICH DO NOT <u>EVOKE</u> THE VALUES. **THE PITFALL TO AVOID IS SEEING THE IMAGES AS ILLUSTRATIONS OR SYMBOLS OF THE VALUES - IMAGE CONTENT IS IRRELEVANT IN THIS EXERCISE. WARNING SIGN:** YOU FIND YOURSELF JUSTIFYING THE CHOICE OF AN IMAGE BECAUSE "IT HAS THIS OR THAT QUALITY" - THIS EXERCISE IS INTUITIVE NOT RATIONAL.

- AS THE EDITING CONTINUES, ONE OR TWO IMAGES WILL START TO STAND OUT AS ENCAPSULATING THE DESIRED VALUES. SET THESE ASIDE.

- START CLUSTERING AROUND THESE IMAGES. WHAT YOU ARE LOOKING FOR ARE IMAGES THAT HARMONISE AND INTEGRATE IN SUCH A WAY THAT THE WHOLE SELECTION CAN BE TAKEN IN ONE GLANCE. **WARNING SIGN:** IF ANY IMAGE JUMPS OUT, OR IF THE EYE MOVES AROUND THE SELECTION, RECONSIDER THE SELECTION - ANY IMAGE THAT PREVENTS THE WHOLE BEING SEEN IN ONE GLANCE IS CONVEYING DIFFERENT QUALITIES.

- TEST YOUR SELECTION BY MOVING THE IMAGES AROUND THE BOARD TO ENSURE THAT YOU ARE NOT CREATING A COLLAGE - **IMAGE POSITION IS IRRELEVANT IN THIS EXERCISE.**

- USE THE MOOD BOARD ON THE FACING PAGE TO BENCHMARK ANY PHOTOGRAPH YOU HAVE. **Place your photograph onto the mood board and notice if it harmonises or not, ie. does it draw the eye to itself or does the eye start to move around? If it doesn't, the values evoked by your photograph and those behind the board are likely to be similar. Try the same with any logo.**

ABOUT THIS MOOD BOARD.

ONE: It is different from what is commonly called a mood board. TWO: It is not intended to *stimulate ideas*, but instead to *evoke a feeling*. THREE: It is an exercise in intuitive looking – not only must the eyes and mind be open but also the heart.

There are three ways of obtaining a photograph: one is to find it, the second is to commission it, the third is to take it yourself.

To go the second or third route is to assume that the image you want does not already exist.

Here we explore the implications of commissioning.

It is generally supposed that commissioning is more expensive than buying from stock, but with the rise of reproduction fees over the years, this is not always the case.

Where and how do you find a photographer?

• **The photographer visits.** Try and make time to see their work. In some agencies, the Creative Director never gets to meet the photographer. Others ask for a portfolio drop-off. What has been missed here is the ability to assess why the folio work looks like it does, or what the photographer's personal work looks like or even what the photographer actually loves doing.

• **The photographer's agent visits.** The agent is characterised by powerful biceps and a neat line in patter. They carry around the work of a number of photographers on their books and so the viewing can be somewhat discursive. It must be remembered that the agent's first client is the photographer.

• **Photographer's promotional cards.** Every design studio has a huge pile of cards sent regularly through the post. If you collect these cards, make sure that you file them or display them in a way that the memory can constantly be jogged.

• **Directories.** Each year, several annuals and directories are published in which photographers advertise themselves. An example of this is the *Art Directors' Index to Photographers* (published by Rotovision) which gives unequalled, global coverage of professional photography.

• **The network of designers** is a useful source. You might find it helpful to speak with your colleagues to glean ideas and contacts.

• **Antenna.** Don't forget to keep looking in magazines, billboards, etc.

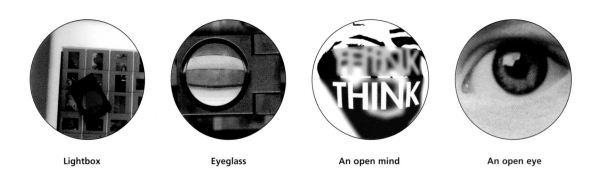

Lightbox Eyeglass An open mind An open eye

These will come in handy when viewing a photographer's work

...SO NOW YOU'VE IDENTIFIED TWO OR THREE
PHOTOGRAPHERS WHOSE WORK FITS YOUR BRIEF...

Briefing the Photographer

A number of photographers like to be briefed face to face, to talk over the project, and perhaps to suggest variations. Depending on the job, the designer would either have a visual of what is wanted or would have formed a working relationship with the photographer so that the photographer can be left to their own devices.

A tight brief or a loose brief; both have their merits and pitfalls – too tight a brief could snuff out the contribution of the photographer, while too open a brief could leave the photographer floundering. It is necessary to know the photographer before deciding on the kind of brief with which they will feel most comfortable.

At this point, a word on the vexed subject of copyright is in order.
• The photographer's quoted fee covers the right for the use of their image in a designated medium. So, do not be surprised if their fee varies according to whether the image will be used on the front cover of a publication printed in tens of thousands or on the inside of a small leaflet.

* The copyright of the image remains with the photographer unless otherwise agreed. Just because you have commissioned an expensive photograph for the front cover of your annual report, it does not mean that the photograph is available for your firm's Christmas card, your trade exhibition stand or any other promotional exercise. For these other uses, separate rights would have to be purchased. Equally, the photograph is not yours. If you wish to hang the photograph in your client's boardroom, a separate price will have to be negotiated.

'Selling' the Photographer

It must not be forgotten that in most cases the client holds the purse strings and will ultimately give the green light to the project. There are ways of selling a photographer to a client:

• Take along a selection of the photographer's work and try to inspire the client with its qualities.

• Present visuals with images 'like the ones we're going to use' pasted into it. As long as the final product has that look, the client will be happy to leave the decision to you. (There is a downside to this process: the client might actually like the image that you have pasted in – by definition, one that has already been printed in someone else's brochure).

* You may have bought a photograph which hangs in your client's boardroom, but this does not give you the right to use it on the cover of their annual report – the copyright for its publication belongs to the photographer.

• Copyright covers the essential defining characteristics of the image. Thus, using part of a photograph from which the whole could be recognised, represents a breach of copyright. Using a small section of it MIGHT not represent a breach – but it is better to play it safe by respecting the photographer's rights.

* Distorting the photograph in any way, without the previous agreement of the photographer, could represent a breach of copyright in some countries.

The Shoot: A designer's viewpoint

There are some occasions when the image in the designer's mind is so precise that the photographer is reduced to the role of highly-skilled technician, in which case it will be essential for the designer to attend the shoot.

For still-life and shoots involving models, it is always advisable for the designer to attend. For shots where the photographer is required to capture mood in a reportage style, the role of the Art Director is limited.

The function of an Art Director on a shoot can vary. They can play the role of mediator or fixer, generally making sure that distracting influences are removed so that the photographer

A SHOOT CAN BECOME A BUSY PLACE. THERE COULD BE A NUMBER OF PLAYERS ON THE STAGE...

THE PHOTOGRAPHER
THE CAPTAIN OF THE OPERATION. CAN COME IN A RANGE OF PERSONALITIES: QUIET AND THOUGHTFUL, DICTATOR, PRIMA DONNA, PERFECTIONIST...

THE ASSISTANT
USUALLY A TRAINEE PHOTOGRAPHER. PRIMARY ROLE IS TO RELIEVE THE PHOTOGRAPHER OF THE TEDIOUS TASKS. FETCHES, CARRIES, ADJUSTS LIGHTS, MOVES PROPS, MAKES COFFEE, CHANGES THE CD MUSIC, GOES OUT FOR THE BACON SANDWICHES...

THE MODEL
LIKE THE PHOTOGRAPHER, ANOTHER PERSON THAT NEEDS PAMPERING. IF THE JOB CALLS FOR A MODEL, YOU WILL FIND THEY COME IN ALL SHAPES, SIZES, NATIONALITIES, AGES... AND, OF COURSE, RATES. (WE ARE NOT NECESSARILY TALKING ABOUT THE SUPERMODELS. A MODEL CAN BE ORDINARY.) THEY USUALLY ARE FOUND IN AGENCIES AND COULD BE CHOSEN BY THE PHOTOGRAPHER, DESIGNER OR EVEN CLIENT. THERE ARE MODELS THAT SPECIALISE IN HANDS OR FEET OR LIPS OR BOTTOMS OR LEGS. DO NOT BE ALARMED WHEN YOU FIRST SEE THEM AT THE DIFFERENCE IN THEIR APPEARANCE FROM THE AGENCY CARD... THEY WILL BE WORKED UPON AND TRANSFORMED...

To attend or not to attend...

that is the question.

can get on with the job of creating great pictures.

At other times, the Art Director gives feedback and direction so that the image in the mind's eye is achieved.

Clients need to be warned that if they wish to attend the shoot, they must be prepared to put up with

long and tedious waits while the photographer takes light readings, moves a piece of gel, adjusts a prop three millimetres, moves a light six feet, changes the backdrop, takes the polaroids and generally engages in the mysterious things a photographer engages in. The main task for the client is to approve polaroids.

THE MAKEUP ARTIST
PERFORMS A MINOR MIRACLE ON THE MODEL. THEY DO THEIR HAIR, PAINT THEIR FACE, DRESS THEM AND GENERALLY TRANSFORM THEM INTO THE CHARACTER THEY NEED TO PLAY FOR THE SHOT.

THE SET DESIGNER/PROPS
THESE ARE THE PEOPLE WHO CREATE THE ILLUSION IN THE STUDIO. THEY CAN BE INVOLVED IN BUILDING COMPLETE ROOM SETS WITH FIREPLACE AND ARMCHAIR, OR FINDING THE RIGHT OBJECTS, LIKE KNIVES OR BASKETS, OR CREATING PAINTED BACKDROPS WHICH COULD BE REALISTIC OR IMPRESSIONISTIC. THEIR EYE FOR DETAIL CAN SOMETIMES MATCH THAT OF THE PHOTOGRAPHER.

THE FOOD STYLIST
A FOOD SPECIALIST WHO WILL BUY, COOK AND PREPARE FOOD FOR A FOOD SHOT. THEY USUALLY ALSO BRING ALONG THE CROCKERY, CUTLERY, NAPKINS, ETC., TO COMPLETE THE ILLUSION.

All of the above could typically be involved in a studio shoot. Location photography is not usually as crowded – sometimes just involving photographer, assistant and models OR just photographer and assistant OR the lone photographer.
Whatever the setup... it's all there just to serve the inevitable...

The shoot: an assistant's viewpoint

You have to keep on your toes and bring a picture up a notch above the client's expectations. This is what makes the reputation of a top professional.

Models: Who chooses a model varies – usually the decision is that of a committee, following casting sessions arranged by the ad agency looking for a 'new face'. In fashion catalogues, such as Kingshill, the clients books the girl; in Unipart calenders, we do the casting. The sessions can be three days long, involving 80 girls a day. We film this on video and from that whittle it down to 20 girls, who we call back to shoot on polaroid. Out of these we present 8 to 10 to the client.

The personality of the model is important it can sometimes be the deciding factor: a less pretty girl able to project herself will be chosen above someone prettier but demure. Some of these girls should be actresses, they're so good at taking the part. This is why some models are what you might call 'striking', rather than classically beautiful.

Editorial and advertising work throw different challenges at you. Yes, you have more creative freedom with editorial, and sometimes advertising work seems like nothing more than an interpretation of the layout, but it can be just as satisfying to meet the technical challenges and to fulfil the brief. Editorial shoots can be too loose, the brief too open-ended, and then you spend the shoot getting worked up about how the pictures are going to be received, suffering fear of rejection.

Working with designers: Patrick loves designers and does not mind his pictures being worked on, especially if it is discussed at concept stage so that we can meet half-way. Sometimes, for instance, we shoot in black and white, knowing that hand-tinting will be required.

Sometimes I put some black and white stock out in case half-way through the shoot Patrick suggests sepia-toning or hand-tinting to the designer, and then we will need to do a roll of black and white.

He is very very happy working with designers and art directors. We had a terrific relationship with Noel Myers of Unipart, but he died on location in Cuba in '93, and we lost a great colleague.

We've been around the world on location and seen some sights, but the most difficult job we've had was Stockton on Tees, a profile of the town done for the Development Corporation. It was a three-week shoot working hand-in-glove with the designer.

What the photographer wants from the designer is the nod, the wink and the thumbs up, to know that everything is going OK. Reshoots are demoralising.

Research and recces are vital. Patrick is very keen on recces. They are incredibly important. Just knowing where to park the car, for instance, and what props need to be purchased and where.

And then there is luck... At Henley, it was July 4th and suddenly the weather picked up, everyone came out, and it's a nightmare to park. We can't find anywhere to leave vehicles, we're losing time and the shot, but then Henley Regatta Press Office saved us, giving us parking space in a terrific location, from where we got our shots.

Troubleshooting: We were doing a calender for 1999 on the British Season - Henley, Wimbledon, Notting Hill Gate, etc. At one location it rained for days, but we pushed and pushed at it and suddenly it worked for us. This is the nerve-racking aspect. As in poker, you must never be seen to blink. Push your luck, try some

No.11 'SPARKS' DAYLIGHT BAKERY

No.9 Belasis Boames

No.22 Yarm Bridges

Pete Kain is Patrick Lichfield's Studio manager and Senior Assistant. His is a technical and logistical role, liaising with Art Directors and stylists, organising lighting, the lenses, the film stock, doing rekkies on the location and time of day, and bringing back polariods, plus providing all the equipment needed. This absolute luxury allows Lichfield freedom to think of the shot and nothing else. Pete hands him the camera loaded and ready to go, and Patrick is free to think laterally.

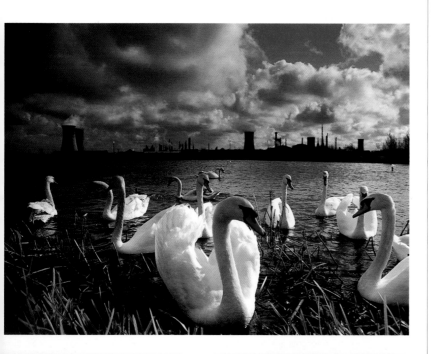

tricks, such as cropping for overcast or flat skies, put elements of silhouette into the foreground, use filters to liven it up, or go for dark and moody. Go equipped. You can't cover all eventualities, but you can be prepared for the worst. There is no affordable insurance against the weather, but you must not fail, so go for something different, save the situation – and that way you end up a hero.

(David) Bailey and (Terence) Donovan had a dinner together once, and were discussing the difficulties faced by photographers, and came up with 450 ways why a photo shouldn't come out, everything from loss of camera, mechanical failure, you name it. In Hong Kong recently, the driver who came to pick us up from the hotel was 15 minutes late, and then it turned out that he did not know how to find the location. In pro situations, everyone needs to play their role to the full. Being late should not happen.

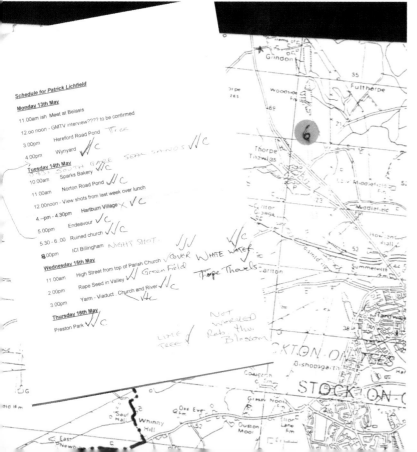

The shoot: a food designer's view

Susan Tilley (food designer) and John Street (photographer)

I find myself in an unusual category, with my forte being in the designing of food for photography. 'Designing with food' as opposed to just 'food styling' has become the focus of my work.

'Food styling' is the art direction and presentation of food for photography in its classic sense, showing the ultimate in appetite appeal. The Spring Valley Juice billboard (below) is an example. It portrays the food as the consumer would aspire to create it themselves, with the photographer providing mood through lighting and focus to evoke the desired emotive effect.

'Designing with food', on the other hand, does not necessarily involve creating appetite appeal – it is purely an illustrative art form. As the medium, i.e., the food itself – is transient, the role of the photographer becomes critical if the image is to have any permanence at all.

This makes it important to establish a relationship with a photographer that has empathy with the designs, as well as the technical skill to perfectly balance every nuance of lighting perspective and focus to complement the design.

Over the years John and I have developed a unique relationship – an almost telepathic, artistic understanding that aspires to achieve the finest results possible.

Sometimes the designs involve highly complex sets with multi-tiered layers of glass. They demand a lot from the team: myself, the photographer and the assistant. The 'Tahiti' landscape was typical of one of these complex sets. It is recorded on a 10 x 8 inch transparency with no use of computer technology to retouch the image in any way. This purist attitude is a thing of the past as it would be foolish not to use new technology to correct small details or enhance or alter some effects.

Most food stylists are responsible for obtaining and arranging both food and props with at least equal input as the photographer in the art direction of the shot. In my experience, the more experience and respect the food stylist/photographer team has, the less the client becomes involved.

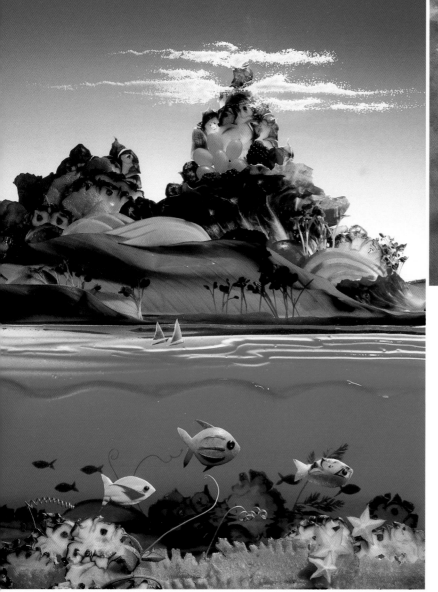

LICK!

selecting the image

The contact strips arrive. One picture needs to be chosen. Here is where the eye-glass comes into its own. And the mood board or a list of the qualities you are trying to evoke.

In this example, the brief was to project the qualities of:

VITALITY
FELLOWSHIP
SELF-DISCIPLINE

Out of a full afternoon session (which includes getting to the location and returning) only one shot was usable for this brief...

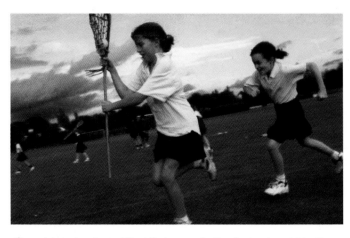

The picture has been tilted 7 degrees in the frame to add to the sense of excitement and vitality.

In this example, the number of variants are beyond the control of the photographer. On the next page we show how, even in the relatively controlled situation of the studio...

possible

better colour but content is not right

girl appears to be smelling armpit

cannot see the point at which action is taking place

looks too aggressive ...lacks fellowship

cannot see the point at which action is taking place

right direction but girl's face hidden

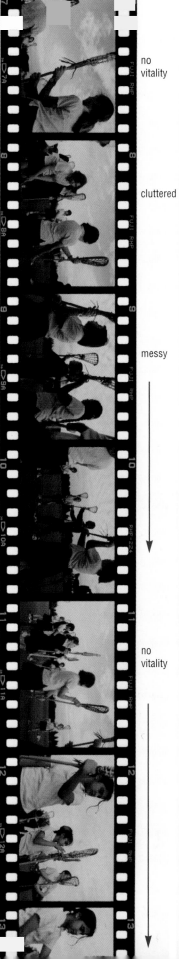

no vitality

cluttered

messy

no vitality

No vitality

Teacher appears to be grabbing girl

wrong shape

nothing happening

no visual focus

75

Route #1: commissioning

On the previous page, the composition of the picture determined the choice. Different factors come into play when making the choice for a portrait...

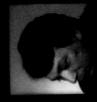
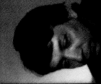

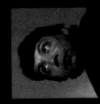

...the basis of choice is the extent to which the sitter's qualities reflect the image that is appropriate for projection for the particular project – in this case a designer who is sympathetic with photography.

Different criteria for choice...

Choosing pictures that are less descriptive and more emotive becomes a slightly different task. Here the taste or instinct of designer becomes more important in the decision-making process.

In the example on these pages, any number of the photographer's images might have fulfilled the brief. This is when questions of symbolism also start to come into play. People who know the subject of the opera will bring their own interpretation as to whether the final image represents of the subject matter. And there will be divergent views.

The question we could ask – but one not asked often enough – is:

'Does the feel of the image evoke the feel of Mozart's music in *The Magic Flute*?'

You might decide for any number of reasons to find a picture from the pool of images in existence. These include **(a)** stock libraries, **(b)** photographers' agents, **(c)** the back catalogue of the photographers' own collections and **(d)** copyright-free CDs. Increasing (but not covered in this book) are free images on the internet. We start off with an overview by Harold Harris...

Picture libraries arrived with illustrated stories in magazines. News and feature syndicates began to offer individual pictures, and demand grew for certain categories. Louis Aarons for example, a French photographer, took babies in the 50s and 60s as speculative work. These were taken round the magazines by photographers' agents, who then became known to have such pictures.

Some began to specialise in landscapes - good for jigsaw puzzles and calenders - or sprays of flowers for greeting cards, with a blank space in the top right-hand corner. I think this is where Tony Stone began here.

By the late 70s there came a creeping professionalism, and agencies began to look for prime photography rather than off-shoots (off-shoots are the ones left after a commission shot has been chosen). It was Stone who stopped this habit (of using rejects to form stock) and we all owe him a debt of gratitude. After that, photographers began to shoot specifically for the library.

Growth was inhibited in the 80s. Photography became over-priced – studio hire was a thousand pounds a day. Ad agencies preferred to commission than to pay library rates. The bubble burst. But out of it came good stock photography. The best photographers were recruited to give one or two or three good pictures for use in catalogues,

Just in case you might get the idea that this book's premise of a spectrum of imagery from 'primarily informative' to 'primarily evocative' has no relevance when it comes to stock images, the next spreads shows that, even here, the spectrum applies...

Harold Harris has been in the picture business for many years, and for most of them ran the UK branch of the German agency, ZEFA. He sold to Stockmarket, USA, but continues to run the London office.

and
catalogues took off in the early
80s. Everyone in the business noticed if a
picture was repeated year after year, spotted it as
a seller, and sent someone off to do one like it for their
collection.

There were too many photographers at the time. Anyone with a Nikon could call himself a photographer. A lot fell by the wayside, but good agencies had the material.

Catalogues are used by designers for ideas, and they take them to client meetings. But even catalogues are changing. The pictures are becoming more creative and innovative. There are two kinds of photography – the easily-had and mechanical kind, and the difficult stuff. The former is going to become much cheaper, because of their availability as clip art and off the Internet. Agencies will concentrate on the difficult photographs which are the result of hard work, and make their money with those.

Bring on the stock catalogue 'WOMEN'!

>>

Women in the Photonica collection

"We stand proudly at the evocative end of the spectrum – we are not terribly interested in fact. The Eiffel Tower in itself interests us much less than an idea which it evoked in the photographer. We say that there has to be some evidence in a picture beyond the simple fact that the photographer was there on the day." Francis Hodgson, Creative Director, European office.

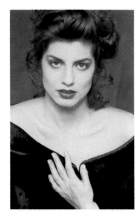
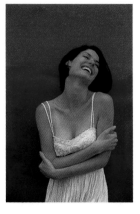
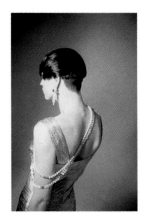

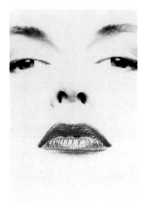
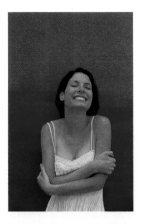

Women in the Stock Market collection

"People ask us for 'something different' for Paris, but we will include the Eiffel Tower in the selection and, more often than not, that is the one they choose." Richard Steedman, President, Stock Market Photo Agency.

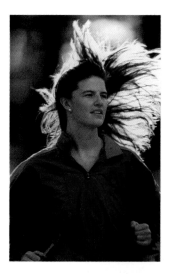

Women in the Roger Viollet collection

Each nation has its great archive. In america it is Culver pictures or Brown Brothers; in the UK, the Hulton Picture Library; in France it is the Roger-Viollet Agence de Presse...

**"Very soon it will be possible to make a selection of our pictures with a computer from any place on the planet."
Henri Bureau, Directeur.**

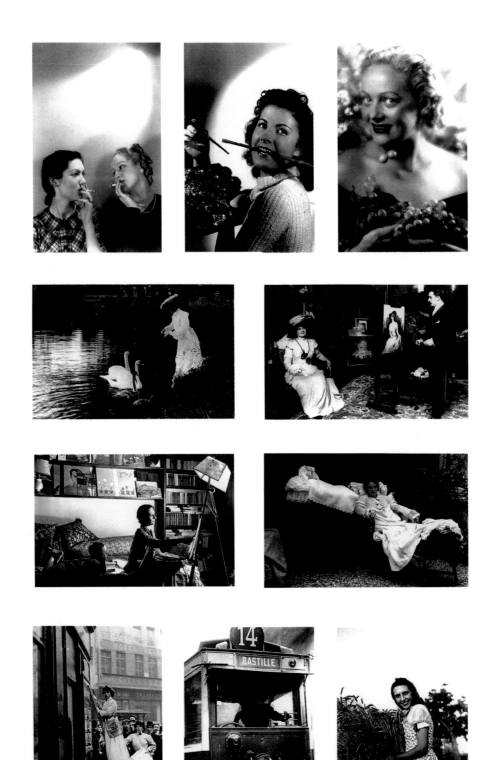

Oxford Scientific: a specialist agency

Whereas at one time one would go to a speacialist agency to get the technical, information-driven image, these examples show how far up the spectrum – towards the evocative end – these agencies can move.

Orange

Serene

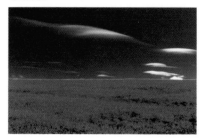

Fundamental

Beyond animal, mineral, vegetable

Ocular

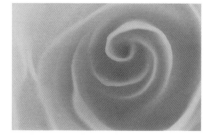

Sensual

Fatale

Beyond animal, mineral, vegetable

Ornate

Spirited

Flamboyant

Beyond animal, mineral, vegetable

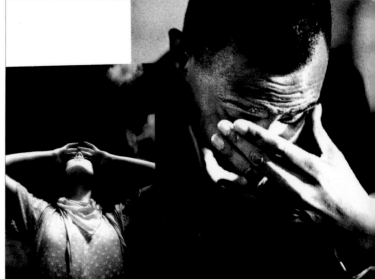

The choice of visual languages narrows down when using a photographers' agent as a source of usable images that already exist. This is quite different from a stock library (despite our demonstration on the previous pages) in that the stock library will still offer a very wide range to choose from.

The agent, on the other hand, has already selected a small number of photographers whose work not only harmonises with the others on the books, but also complements them. This is to allow the agent to build a reputation based on a certain type of work.

So the 'look and feel' is broadly settled – it is either appropriate for the job in hand or it is not.

This spread and the next shows the type of work on offer. (Remember, however, that the agent allows you the additional possibility of using the same photographer to take original photographs if you need them. This is not an option available if you go down the stock market route where the identity of the photographer is not known.)

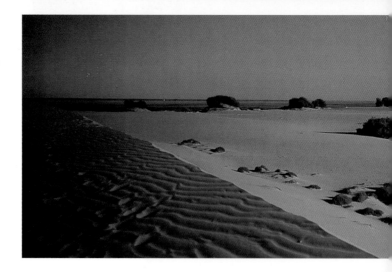

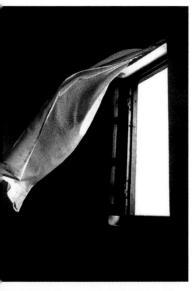
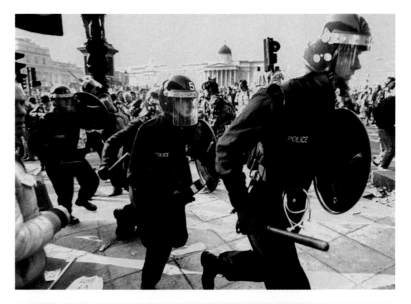
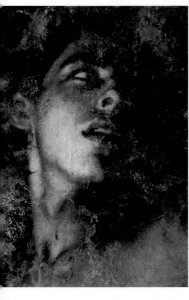

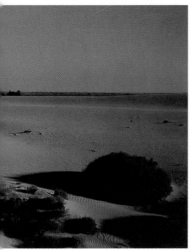

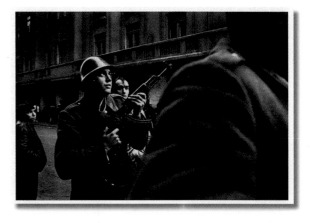

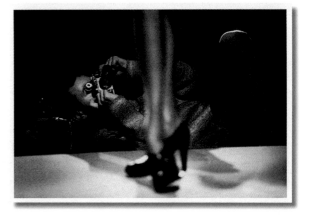

"Network's income is 50% agency, 30% stock and 20% international sales. As an agency, we still send photographers out on the scent of a story. When Jillian Edelstein, for example, suggested a feature on the victims and perpetrators of apartheid (see page 44), apart from some interest shown by the New York Times, she went off to do the story with no guaranteed sales. Network believed in the story. The results were bought by 10 countries and won the Palm d'Or at Perpignon.

"Photo-journalists are extremely focused people who know what they are doing. They have a surprising degree of sophistication – part image-maker, part journalist. While people often talk about Sebastaio Salgado's masterly image-making – and he certainly has taken reportage photography into new realms – it is the 'journalism' in 'photo-journalism' that most preoccupies him.

"In the hands of a good designer, the inner strengths of the pictures are allowed to work, and the resultant piece is a win for all involved – client, designer and photographer."

Neil Burgess

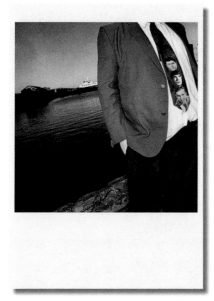

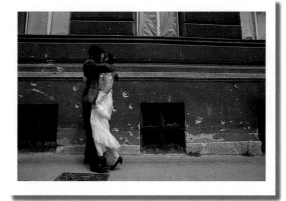

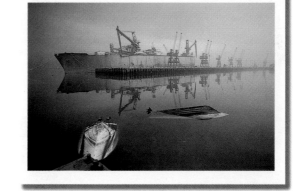

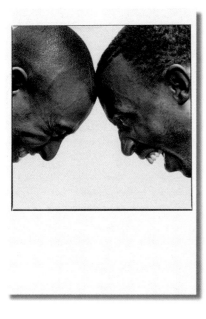

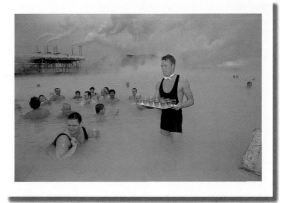

You could be amazed by the treasure trove of images that lie in the photographer's portfolio. They contain pieces that are usually invested with more emotional depth because they are largely work that the photographer has taken to attract work and display their talent. The visual language is now even more restricted than the choice offered by the agent, so the designer's decision needs to be more focussed. *(This spread and the next two shows examples of what has been found in the back catalogue.)*

There are two sources for these sorts of images: the first is personal work – the work photographers do when they are between commissions. The second are off-shoots from commissions – the work that the commissioner does not want. Of this second category, there are obviously only certain types of projects that would generate generic, usable spin-offs.

route 2c: the photographer's back catalogue

Hannah McPherson: (See also page 20)

David Kampfner

I bought my Mac, I got my 35mm scanner and I got Photoshop. Then I moved my filing cabinet and discovered that there were between 10,000 and 15,000 transparencies all mounted up, collecting dust. Some of them went back to 1973 when I could barely call myself a photographer. I scanned in a couple as an exercise and realised that here were pictures that I had never seen enlarged and some of them were quite good. Then the archiving on disc became more serious – I took the

opportunity to retouch some of the niggles and clean up images that had become filthy from having lain around untouched, only moving when I moved home. I posted a few images on a quickly assembled web-site and found that I started to get feedback. This experience has resulted in a couple of initiatives: it has galvanised me into wanting to do more personal work, and it has made me determined to make even more pictures available – it's better than them sitting in a filing cabinet.

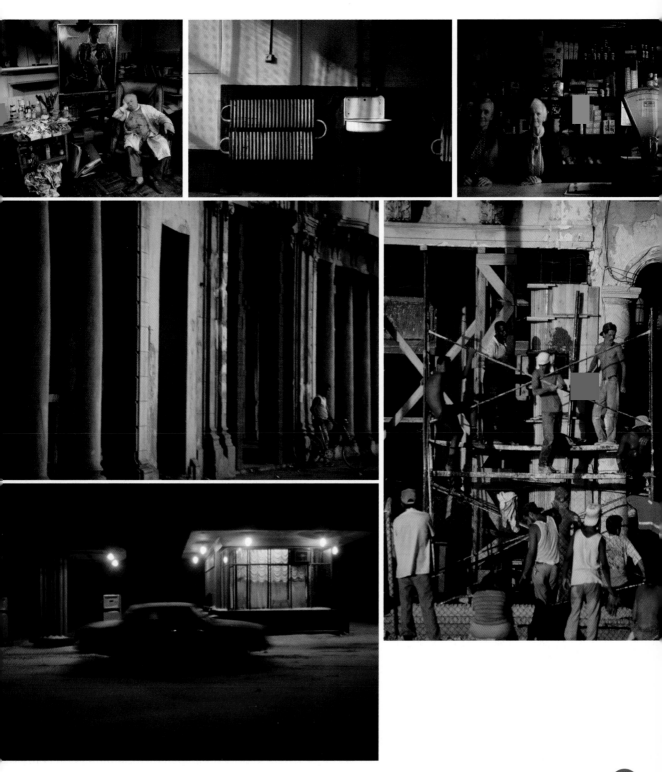

even here the spectrum applies

Run out of time? Budget? Can't find the image you're looking for in the stock libraries or copyright-free CDs? Hate the idea of stock? Then there's only one remaining avenue for photographic images...

Do it yourself

There are a number of more proactive reasons for doing it yourself:

• The image in mind is so well formed that almost any base image will allow you to realise it. The starting image can be weak – in fact the weaker the better – if the vision in mind is clear.

• The visual language calls for images that are more illustrative than photographic.

• There is no great need to make an emotional appeal with the image – it's just there for the sake of simple description.

• There is a need to pace the imagery. Too much of a rich diet might not be the most appropriate route.

• You like taking photographs and you're good at it.

IN PUTTING THIS BOOK TOGETHER A NUMBER OF IMAGES HAVE BEEN TAKEN BY OURSELVES. SPOT THEM IF YOU CAN. IT MUST BE SAID, HOWEVER, THAT NOT ONE OF THEM HAS BEEN LEFT 'RAW'!

RAN OUT OF TIME AND BUDGET. ALSO WANTED A DIFFERENT PACE IN THE BOOK, ESPECIALLY AFTER THE RICH VISUAL SPREADS OF SECTION 2. OUT COMES THE POLAROID CAMERA...AND WE HAVE IMAGES FOR PAGE 68-69.

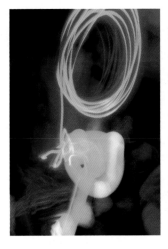

THIS PICTURE WASN'T EVEN PHOTOGRAPHED – THE EYEGLASS WAS PUT STRAIGHT ONTO THE SCANNER AND SCANNED (PAGE 64).

SOME WOULD CONSIDER THESE TWO IMAGES GOOD ENOUGH TO USE AS THEY ARE, BUT THE DESIGNER USED THEM ONLY AS A STARTING POINT (SEE PAGE 101).

A number of new wave design groups like Tomato (profiled on pages 146-147) and new media designers like Dogs (see page 36-37) spend a lot of 'off-time' snapping images as they see them. Their work gets its strength from this approach. On the next spread we show a quieter approach using self-generated photographs...

Yuki Miyake

When I was thirteen, my father bought me the camera – Cannon AG-1. Since then I have recorded my experiences wherever I went. There must be millions of pictures in this world, taken by various people in different situations. I guess I love being a graphic designer because I'm able to choose any kind of pictures for my projects. In the '80s, when I worked in Tokyo, I was only allowed to use images taken by professional photographers. It's now '97 and computers are here. Everyone can be a graphic designer, everyone can be a photographer using the 'Digital Darkroom'.

My emphasis on the Mac is not a technological matter – it's about generating ideas and developing aesthetics. The possibilities and choices are shaped by the circumstances of the brief. Can I find a photographer just right for this job, quickly? Can I explain my emotion and visual language to the photographer well? Is there enough budget? And time...?

So, just load film into camera, shoot and scan in.

Grey council block meets holiday brochure brightness. This is possible in my head and in my computer.

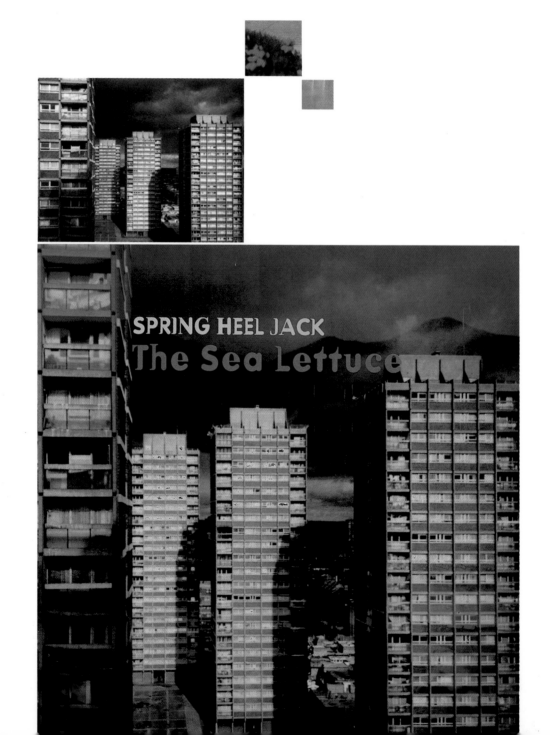

SPRING HEEL JACK
The Sea Lettuce

1 Take 1

2 Midwest

3 60 Seconds

4 Pan

5 Plates

6 Bar

7 Eesti

8 Roger Tessier

9 Island

10 Suspensions

11 Take 2

12 Take 3

all tracks written and produced by Coxon/Wales
Engineered upstairs at the Strongroom by Mads Bjerke
Published by Copyright Control/Redemption Songs
sleeve by Yuki Miyake/System Gafa

DIVE

Steven Williams and Tony Lee

We'd never dream of using stock shots. If you have an image in your mind – and sometimes our images are incredibly complex – you have no option but to control all the elements yourself.

The Client wanted to parody sci-fi/action film posters from the 70s, and establish recognisable characters, who would appear in subsequent releases. The entire 'stage' was created in a virtual 3D studio. The Robot was designed separately and then placed inside the scene. 35 'virtual lights' were then positioned to light the stage. The cityscape and environmental effects of haze and fog were then added as a backdrop. A rough guide printout was then used to shoot the figures in position. These were retouched and comped together in Photoshop, and motion blur effects added to clarify the point of focus.

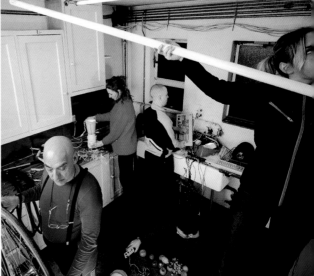

Source material: London Tube map, brass voltage dial casing. No photographic budget

The company had a limited publicity budget and one commissioned photograph [Paul Tyagi]. In order to emphasise the hypnotic intensity of the mutimedia production and open open up the original composition to accommodate text, the scanned image was first distorted in Photoshop. The images for the circular icons [originally simple bullet points] were also grabbed from the original image, and worked back into the design.

Cover for compilation album for London-based music label. Original image supplied as a out of focus polaroid. The basic graphic was traced from a scan of the photo, then taken into photoshop. A small piece of aluminium panel was scanned and used to create the impression of hung steel panels, onto which the image appears to be projected.

section **4**

What designers do to images

In this section we look at what happens once the image gets into the designer's hands.

We have used 5 photographs – one of which is a 'problem' image – and explored the effects of scale, type, colour, juxtaposition and cropping.

The idea has not been to create award-winning visuals, but to observe the effect that changes have on the photograph and the effect that the photograph has on the layout. So the layouts, grids and type have been kept simple – no complex manipulation or layering has been used.

If this had been a thicker book, each change would have been given a spread of its own so that the viewing is not influenced by any other imagery. But this is not a fat book, so the reader is encouraged to isolate each image and observe the effect it has.

The same picture can be used to create a different emotional impact simply by adjusting its size in the space...

cool

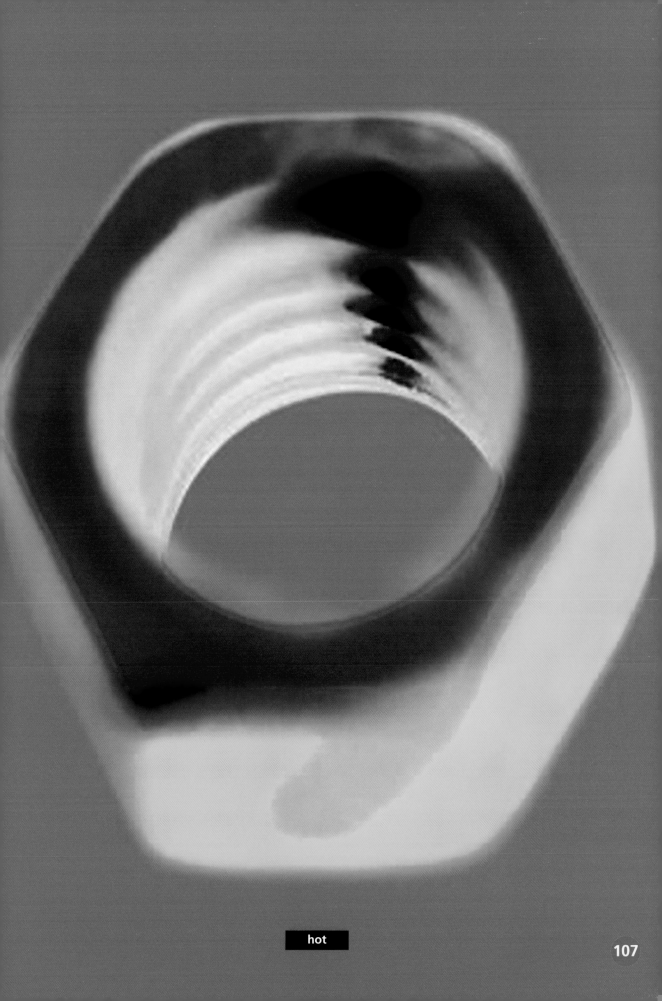

hot

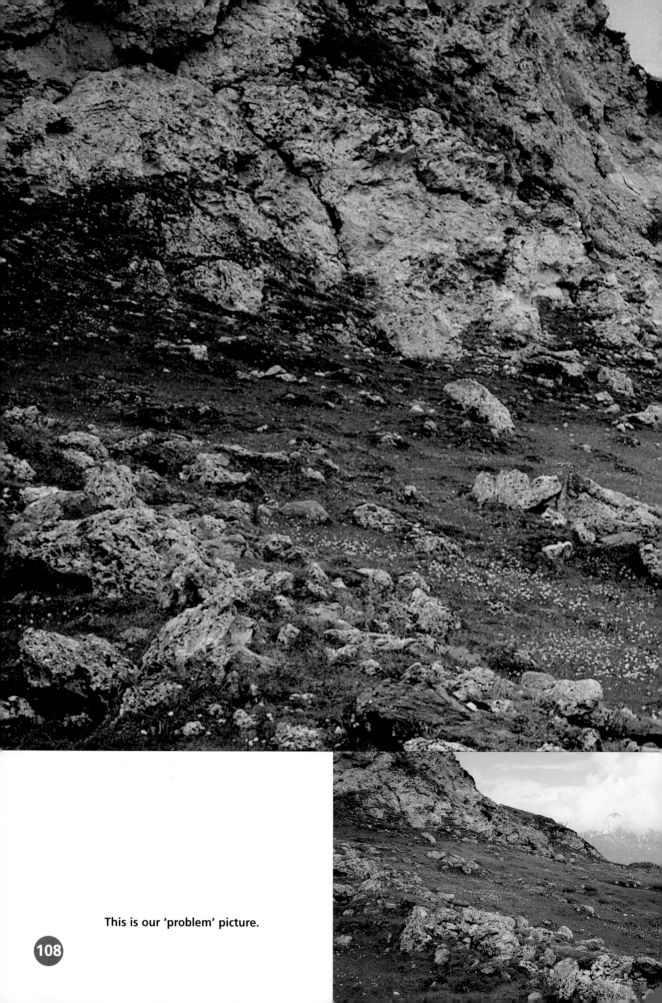

This is our 'problem' picture.

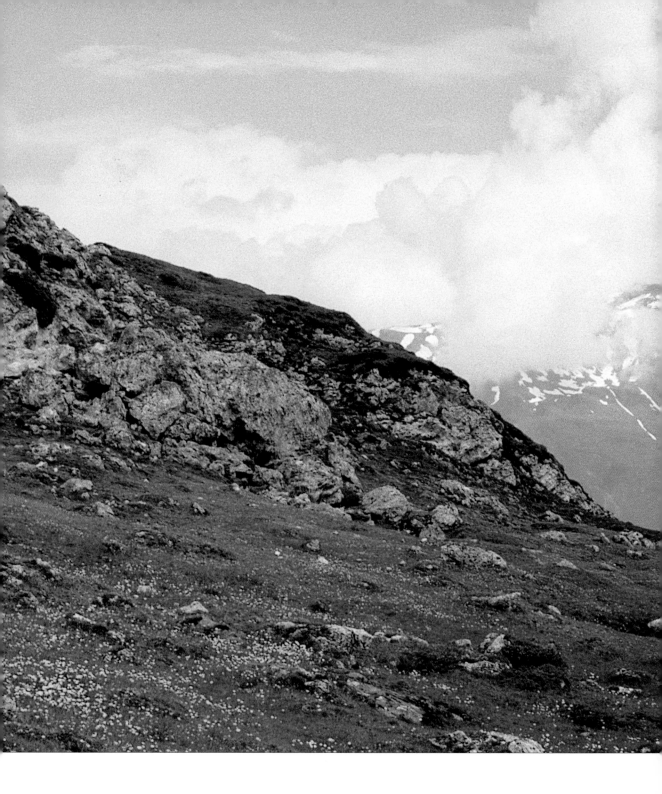

There are no absolute rules... This picture is emotionally neutral and enlargement will not improve it a lot. The dramatic difference that was created by the enlargement of the images on the previous spread does not manifest with the enlargement of this picture. **Large or small, the emotional impact remains neutral.**

The degree of enlargement within a given space will also have an influence on the visual impact. In this example, whilst both pages have a dramatic impact, the enlargement on the right brings out the qualities of openness in the sitter more clearly... *if openness is the quality you wish to project!*

"Hello, I'm Gillian. I'm here to help you."

The same picture can be used on different colour backgrounds to create very different emotional impacts...

yellow

100c **100m** **50c100y**

What qualities are evoked through this bright pallet? Are they the qualities the client needs to project?

Yellow and black are dramatic contrasts used to emphasise the difference colour can make. But the true impact of each colour is distorted by viewing these pages as a spread. To get a truer sense the emotional difference colour can make, view each page with the other covered...

black

100c60m10k **40c100m** **50c10m20y25k**

Your client wishes to promote a range of cheap hardware... Is this colour pallet appropriate?

The mood of a page cannot be attributed to just the colour, the layout or the typography. For the page to work, the visual mood of the picture has to fit in as well. In this example, the mood of the picture is at odds with everything else.

yellow

100c **100m** **50c100y**

The bright pallet clashes with the sober tones of the picture.

black

The key lesson from these pages is that the designer's work of setting a visual mood through type, colour, grid, etc, could be undermined by a picture that does not fit the mood – even though the picture is used

sober pallet does not clash with tones of the picture.

100c60m10k 40c100m 50c10m20y25k

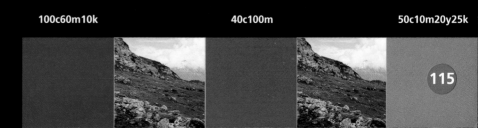

It is necessary to employ a typographical caricature in order to make the point more forcibly.

COMPARE THIS PAGE TO THE LAYOUT ON PAGE 112. WHICH ONE OF THEM WOULD BE MORE APPROPRIATE FOR A CORPORATE BROCHURE AND WHICH WOULD BE MORE ASSOCIATED WITH A STYLE ITEM?

On this sort of page, the role of the image becomes secondary. It has been reduced to colour on the page. There is nothing right or wrong with this role... it is simply a matter of noting what happens.

The type on the page needs to stay in black for the sake of easy translation for foreign editions, so you will need to use your imagination to visualise the effect of coloured type.

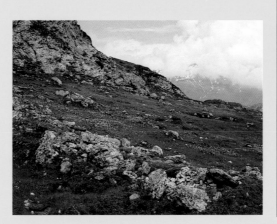

Ways of
working with
this picture are
explored later
in this section.

HERE THE VISUAL LANGUAGE OF THE PICTURE IS NOT CONSISTENT WITH THE YELLOWNESS OF THE PAGE AND THE TYPOGRAPHIC LANGUAGE. A DISHARMONY IS CREATED.

The effect of discordant elements is that the eye is drawn to
one at the expense of the others. In this case, the eye keeps
being drawn to the photograph. Observe how much easier it is
to see the facing page as a whole without picking out
individual parts – making it easier on the eye.

These typefaces do not speak in the same visual language as the picture, the grid or the background colour.

Remember, however, that discordant elements – type, image, colour – create a tension. And sometimes the tension is deliberate.

With inappropriate type even a strong image can be undermined. This has now become a fairly dull page, even though we have seen how the same layout, colours and picture can be used to create a more dramatic effect.

In the context of a travel brochure, however, this type would not be considered wholly inappropriate...

It is interesting to note how – using a picture described as neutral and typefaces described as inappropriate – this page feels more integrated than the facing page.

Despite the improvement, the page is not one which will attract a shower of awards on the designer.

Once the background colour and picture are changed to match the visual language of the typefaces, the page begins to look better. In assessing a layout, the key is to notice which element - if any — distracts the eye.

So far we have explored layouts using a single (untampered) image and one basic grid. No other visual element apart from the type has been introduced. We arrived at a point where, despite an improvement to the page using the landscape photograph, there was still something lacking. **The next step is to build complexity by introducing new visual elements and observe the impact they have.**

Visual elements include other photographs, illustrations or graphic devices. The purple lines and the 'tear' edge on this page are visual elements.

Earlier it was asserted that bright colours were not consistent with the visual language of this picture. Here we see how the addition of other graphic elements can allow the picture and colours to work side by side. Thus, using a neutral picture and a very basic level of graphic addition, we have managed to get a workable design for a postcard.

Note: We have pushed the image further down towards the 'style' end of the spectrum, but have not pushed it so far that the information is obscured by effect.

Rachel Cartland

Passion in Provence

On this page we have used our 'problem' picture with a typeface that 'did not work' before; we have given it a context – a romance fiction cover – and added a couple of new visual elements to create a whole in which the individual 'weak' elements 'work'.
Note: In this usage, the landscape picture is virtually invisible.

"Hello, I'm Gillian.
I'm here to help you."

These pages and the ones before show how much more can be achieved — using the most simple of juxtapositions — once we start adding visual elements. The idea of these pages is to demonstrate that the designer can use extremely simple techniques to create a wide range of visual languages. *The choice of image is key — or to look at it a different way, consistency of visual language is key.* There are no right or wrong images, right or wrong typefaces, right or wrong background colours — simply appropriate ones. And these are dictated by the communication need.

If choice of image is so important what happens when the visual language has been set, the space defined, the grid fixed and the corporate typefaces obligatory and then you are given a weak photograph by the client? **In short, how do you get out of a tight corner?**

Define tight corner...

It's one matter to have the budget and the time to commission great photographs. In these circumstances the image will do a lot of work and the designer has largely to get out of the way.

But even on the best of corporate design jobs, the main pictures will need to be supplemented from the client archive or from another source that is not within the designer's control. (This is not to say that the supplied picture is always a bad picture, it's simply that it might not fit the particular mood that is being created through the design and ends up fighting with the visual language that you are using.)

Sometimes, however, the picture might quite simply be bland.

Context – time and place, medium and visual language – all exert their influence. Thus in a high-style mag, in the West, even a fuzzy polaroid over which someone has spilled their coffee would not constitute a tight corner. If the image is being used in an interactive digital medium, one can get away with a lot more because the image does not stay around for too long. In the terms of this book, if style <u>can</u> outweigh content, then there is no corner to get out of.

The focus of this spread, however, is to deal with situations where a balance needs to be struck between content and style – and you have been given a 'problem' picture.

Here's the brief...

Medium: Travel brochure.

Target audience: Retired people.

Subject: Up-market walking holidays in the South of France.

Mood: Classical, cool.

Constraints:
- Picture dimension
 71.5mm wide x 48mm deep.
- Picture from client archive.
- Corporate typefaces: Garamond and Bodoni.

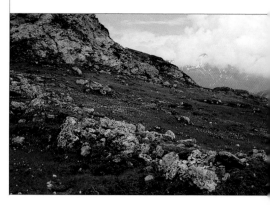

A quick analysis of the potential...

1. The colours are flat. (Enhance?)
2. No section of the picture is interesting enough to be isolated by cropping.
3. The only possibility for cropping is to shave a little off the top and bottom. (But this changes the proportion and will be out of the brief.)
4. The information content of the picture is important (so cannot be obscured).
5. The audience is conservative (so no whacky treatment possible).

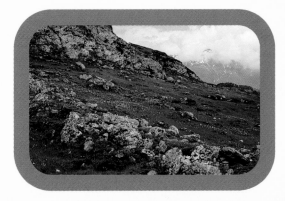

1. Frame

Simply framing the picture will gives it more impact – even here there are colour, thickness and style choices to be made.

2. Lift

Adding a soft drop shadow and tilting the picture gives it a lift.

3. Enhance

It takes under five minutes to adjust the colour levels in a programme like Photoshop.

4. Soften

A simple vignetted oval will make a neutral picture more interesting.

Not a solution for this brief: the content is obscured by style.

Try to get a sense of what emotional change has taken place with each of these simple alterations. This is best done by isolating each image and comparing it with the given picture on the facing page.

South of France

Lorem ipsum dolor sit amet, con sectetuer adipiscing elit, sed diam nonnumy nibh eeuismod tempor inci dunt ut labore et dolore magna ali quam erat volupat. Ut wisi enim ad minim veniam, quis nostrud exerci tation ullamcorper suscipt laboris nisl ut aliquip ex ea commodo consequat. Duis autem vel eum irure dolor in henderit in vulputate velit esse consequat.

Lorem ipsum dolor sit amet, con sectetuer adipiscing elit, sed diam nonnumy nibh eeuismod tempor inci dunt ut labore et dolore magna ali quam erat volupat. Ut wisi enim ad minim veniam, quis nostrud exerci tation ullamcorper suscipt laboris nisl ut aliquip ex ea commodo consequat. Duis autem vel eum irure dolor in henderit in vulputate velit esse consequat.

Without the space and type restrictions of the brief, the image could be stretched and used to create quite a different visual language for a different travel audience.

Je l'aime

126

L'eau de France

Alternatively, a manipulated image from the previous page may possibly be used to label bottled water from France.

What other applications can you see for this image? Theatre poster, corporate brochure, book cover, CD? What type would you use? What other visual elements?

Whatever the final application, the starting point for the designer would always be to be clear about the emotional response that the work needs to get from the target audience.

The key lesson seems to be that there is no image with zero potential!

The previous pages started off with what was considered to be a photograph with restricted potential.

It should now be obvious that a place can be found for almost any image without the need to change it beyond recognition.

This is made possible because the toolkit available to the designer is very large.

Perhaps there is an application for this version after all!

SOME IMAGES CAN BE MADE TO WORK MORE

The bland composition

There is nothing wrong with the picture. Focus, colour, interest - everything is there - but it still looks dull on the page. Time for a good crop. Here we explore a range of images vastly improved by having the distractions removed.

A quick analysis

It is clear that there are many areas that can be isolated by cropping to tell a different story.

1. The helmet can be isolated.

2. The flowers can be isolated.

3. The woman can be isolated.

4. The picture is interesting enough to be used large (see over).

5. Given the right colour background, the picture can be used small.

A narrow crop

This cuts out the dead area of the image so that we can see the important information straight away. It also adds dynamism.

1. The picture is tilted 5 degrees in the frame. This adds even more dynamism.

2. The picture has no tilt – when compared to crop 1, we can see how static it is.

3. To demonstrate that nothing is mechanical, the picture is given a tilt of minus 5 degrees. The cloth on the tomb gives the impression that everything is sliding off to the right. Another picture, however, might not produce the same effect.

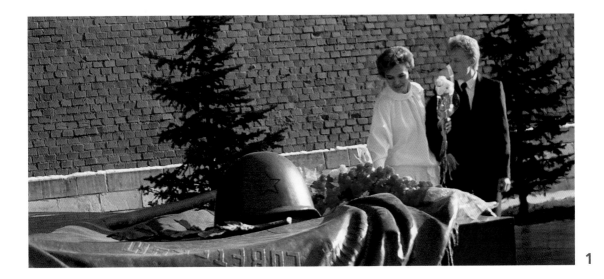

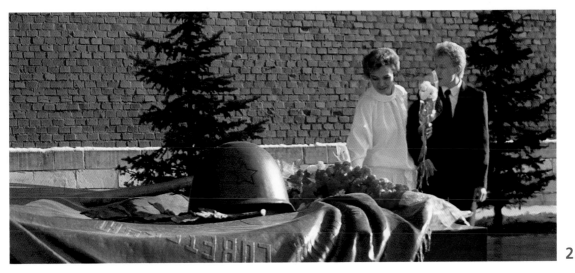

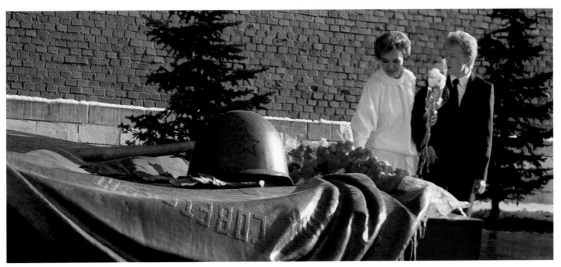

Pictures sp e a k

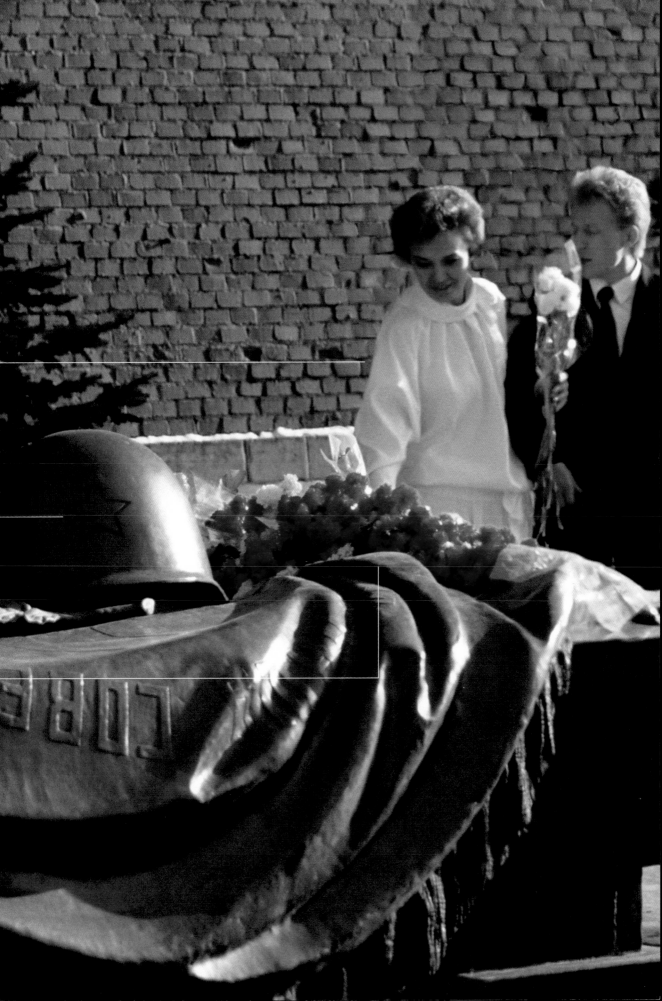

help the pictures sp e a k

section

The design spectrum

As images cover the spectrum from primarily informative to primarily evocative, so design covers a spectrum from those applications where information is primary (e.g., a product leaflet) to those where evocation is key (e.g., posters/hi-style brochures).

This section shows a portfolio of work by graphic designers who specialise in niches along the spectrum.

We work at the end of the design spectrum where the clarity and simplicity of information is of prime concern. Our clients do not expect – nor want – us to spend half the budget commissioning top of the range photographers, because they are interested in getting across information as clearly and quickly as possible. Our approach to photography would reflect this – photography will always be required to play a support rather than lead role.

There are two main areas in which we use photographic images – information graphics (where the studio started) and information literature.

As far as information graphics is concerned, images would typically be used as a background to a map, for example. If the map is to perform its information function well, then the imagery should intrude as little as possible. And if the imagery is to intrude as little as possible, then there is little value in commissioning expressive pictures. We tend to use copyright-free CDs, our own photographic skills, or sections of images grabbed images from client literature. Of course, clients have their own pool of photos – in some cases extending to thousands.

It is rare for us to use these images in their raw form. They will invariably go through some form of manipulation using a programme like Photoshop. Photographs used in this illustrative way get over quite a number of problems – we can change colour, intensity, or remove elements that detract from the prime objective of clarity.

Information brochures we design are not necessarily flagship documents like annual reports or credentials literature. So here too we use photographers who are good at getting the job done simply, cleanly and effectively. We don't use people who are trying to express their own personalities through their images. If you listen well to the client's brief, you will know what's wanted and so you can brief the photographers well.

We choose people who are happy to work without heavy art direction. And clients end up getting the job they want at a standard that's appropriate and within the sort of budgets available. Everyone is happy all round.

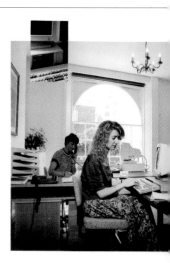

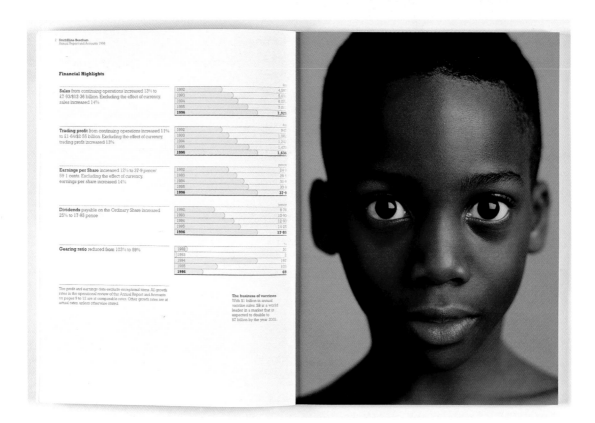

In the financial world there are many audiences: from the professional investor to the 'small' private shareholder. This stretches the use of an annual report. For the flick reader, visual impression is vital, because imagery is a quick way of getting messages across.

It's easier to convince an existing client to be more visually adventurous than a new one. You build on a relationship with knowledge as the foundation. Photography must be seen as being truthful and representative.

Our task is to display the personality of a company, to create a visual style that reflects its qualities and distinguishes it from competitors. Sometimes this is done by using a particular photographer for the job, one whose style then becomes associated with the client. At other times it will require us to reduce the brief to a very simple proposition.

For global clients we are very careful about avoiding the pitfall of using images symbolically. There are cultural differences in how people perceive images. For instance, in the UK an owl represents wisdom, but in Italy it is bad luck.

There are fashion and trends in corporate design as much as anywhere else. The opulent 80s gave way to the gritty 90s and yesterday's fat cats must be seen now as working blokes – it is a much less frivolous approach. Today we use reportage style photography in boardrooms to project a view of natural, approachable people. No doubt, the style will change again, perhaps swing back towards formal.

A photographer's book will sometimes help you to crystallise your ideas on how to express a message. Great work, however, is only as good as the person who produces it, that's why we like to meet any photographer before sending them round the world. In some cases, however, when painting with a broader brush, we use stock images as there is such good stock photography around these days.

The pictures on this and the previous pages were taken during an inspection of the rig being used for the 2/24c well, which was spudded in June.

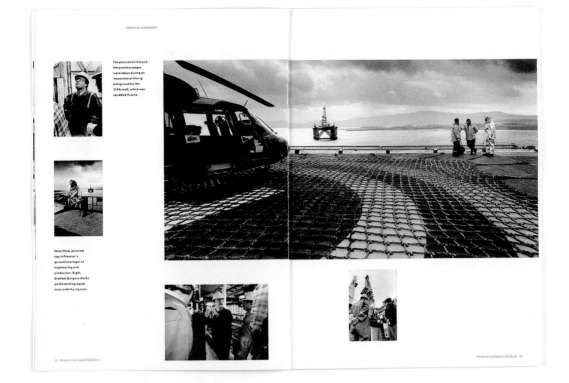

Peter Hind, pictured top, is Premier's general manager of engineering and production. Right, Graham Burgess checks on the tanking equipment with the rig crew.

RELAFEN

9 days

In only **9** days, *Relafen* was introduced to 120,000 doctors in the US. *Relafen* ended 1992 as the third most popular treatment for arthritis pain in the US.

of Varicella zoster virus and Herpes simplex virus infections;

• ropinirole, a treatment for Parkinson's disease, which currently affects some 1·5 million people aged over 60 throughout the industrialised world;

• topotecan, a treatment for solid tumours, including some previously difficult to treat;

• epristeride, a treatment for benign prostatic hypertrophy, suffered by 50% of men over the age of 50.

SB increased its investment in research and development, while realigning its resources to focus on discovery of innovative compounds with the greatest potential. Of the total £478/$836 million invested in R&D, pharmaceuticals accounted for 86%. R&D investment is expected to continue to grow in concert with SB's continued strong performance.

The realignment of R&D during 1992 was the final phase in the creation of a truly global R&D organisation. To target drug discovery with the highest potential return, SB is focusing on four therapeutic areas: neurosciences; inflammation and tissue repair; anti-infectives and biologicals (vaccines); and cardio-

Neurosciences
Seroxat/Paxil (panic disorder)
Seroxat/Paxil (obsessive compulsion disorder)
BRL 48470 (anxiety)
Ropinirole (Parkinson's disease)
Seroxat/Paxil (depression)
BRL 46470 (schizophrenia)

Inflammation & tissue repair
Topotecan (solid tumours)
Epristeride (prostate enlargement)
Relifex/Relafen (acute and rheumatoid arthritis)

Gastrointestinal
OTC cimetidine (heartburn)
Reversible proton pump inhibitor (peptic ulceration)
Kytril (cancer therapy-associated nausea and vomiting)

Anti-infectives/biologicals (vaccines)
Augmentin b.d.
Famciclovir (herpes viruses)
Penciclovir (herpes viruses)
Improved influenza vaccine
Haemophilus influenza type B (Hib) vaccine
Combination hepatitis A & B vaccine
Improved pertussis vaccine Pa (whooping cough)
Inactivated polio vaccine (poliomyelitis)
Varicella vaccine
Paediatric combination (diphtheria, tetanus, pertussis, hepatitis B) vaccine
Havrix (hepatitis A) vaccine
Herpes vaccine

Cardiopulmonary
Pobilukast (asthma)
SK&F 97426 (hyperlipidemia)
SK&F 108561 (hypertension)
Kredex (hypertension)
Kredex (angina)
Kredex (heart failure)
Kelantan (asthma)

Key
Small-scale dose ranging studies in patients Phase II
Large-scale trials to verify safety and efficacy Phase III

(column headers: Phase II | Phase III | Marketed)

The packaging designer has an orderly mind. Space is at a premium and several messages may need to be projected and paced. As a discipline it is a combination of the rational (need for information) and the emotional (need for choice). Photography can embrace both. What matters is the objective, the idea, the tonality. Advertising images are transient, brand images in the context of packaging are more permanent – to be held in the hand, taken home.

The tonality, therefore, becomes more critical as the audience becomes more self-conscious. Successful photography in packaging is evocative, open-ended, allowing the viewer to take out what they will. Our Boots condom packaging is a good example of this.

Alternatively, 'frank' depiction of the product can reinforce the integrity of the brand, as in Duchy Originals.

Compromise is all too frequent in packaging design given the inevitable constraints. As in any medium, a brilliant image will not survive a weak typography or design. All elements must work in harmony, all participants in the design need to share the same vision for it. The designer and photographer have to be single-minded. The idea must remain hero and not get lost.

The photographer must be party to the objectives and have patience in the context of a highly-considered design. Then the boundaries can be pushed. There must be space for the unexpected to happen, for the photographer to extend the idea or amplify it. But the design objective must hold fast.

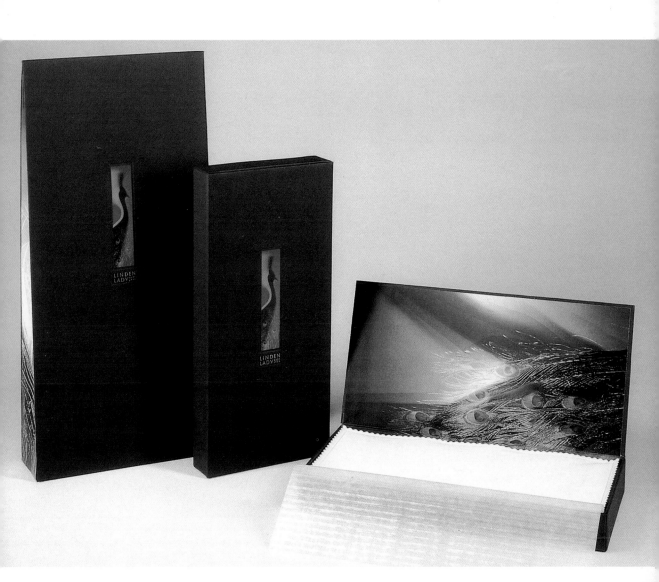

ITALIA
Nudes

Corporate Identity; Literature; Posters; Books

Inspiration comes from understanding the problem. Formulating the problem – that's where the creativity starts. The question is really important. The idea comes as a solution, the rest is all building on the idea. Questions nag, they're with you all the time, in the bath, on top of a bus, in the middle of the night. I keep a note pad next to my bed. Possible answers arise all the time, but reject them, wait for the refreshing answer.

WE ARE FOREVER LOOKING.

We like to use the best, but we also like the newest. Designing for the arts gives creative freedom but does not come with a big budget. We like to work with photographers with whom we are in tune and, in time, this creates a shorthand of communication, but of course this means that work and solutions can become predictable.

One chooses an appropriate photographer, but any good photographers can adapt. A photographer is part creative, part technician. I approach him/her with the thought, here is my idea, how can you make it better? Reliability is so important. Reliable photographers stay with us. Sometimes, through working with us, photographers find a new direction, or their work becomes improved, enhanced.

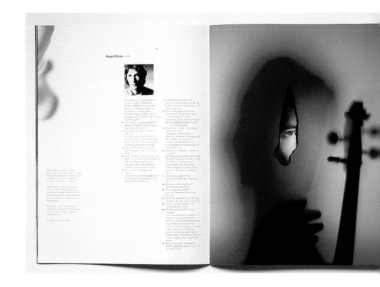

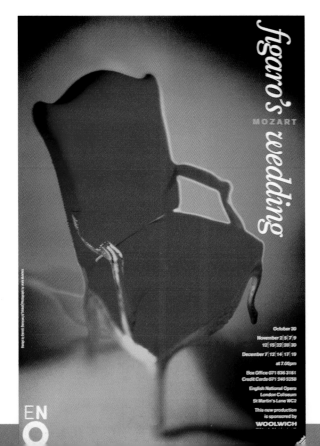

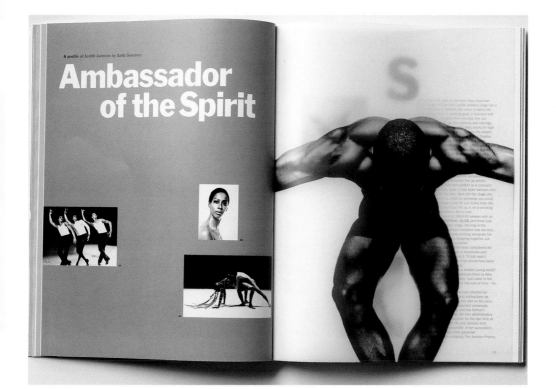

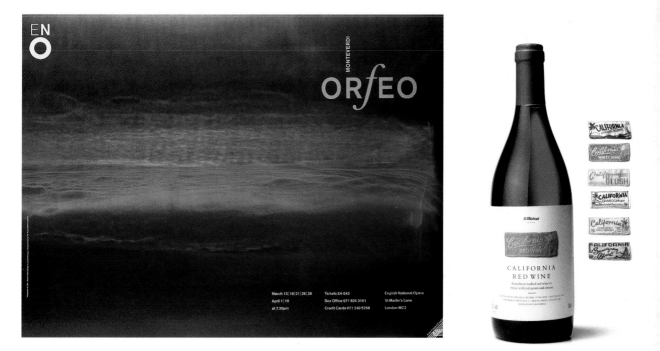

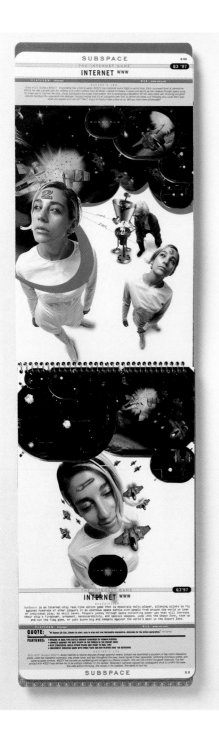

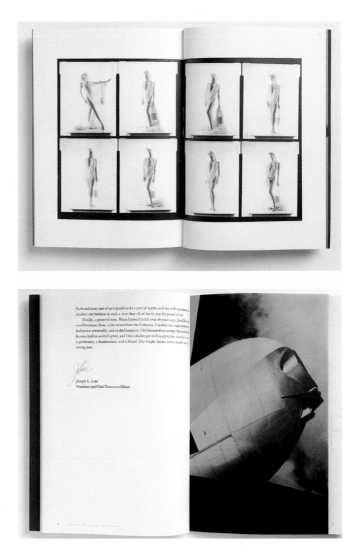

Photography is a means to achieve an appropriate visual solution for a concept. Photography works as an extension of the concept, enhancing its message and impact.

Any photographic contribution to a design is enriched by its thoughtful association with other elements in the work.

Whether stock images are employed or original commissions are composed is not the issue – images are selected or created and then manipulated, evolved into something different, greater than their genesis.

Arild Midthun & Erna Osland: Ivar Aasen Bokomlag for Det Norske Samlaget (*design remix 1996*)

Subtopia started in 1991 as a small, loosely-knit constellation of people working with illustration and design. Our beginning coincided with the arrival of cheaper Macs and software like Photoshop, and the house club scene in Oslo. When it came to designing, more – not less – was definitely more! (In fact, our name was originally intended for a house club that never saw the light of day, and we were stuck with a name, logo, printed T-shirts...)

Our early use of photos was often limited by lack of money within the cultural sector which was, and still is, our main source of work. This, combined with the illustration background that some of us had, led to a way of working where photos were simply visual raw material.

Currently we have three basic ways of working with photographs:

Magazine work: We receive images from photographers who have been briefed by editors. On average we would manipulate about a quarter of these images.

Giving a brief we would prefer to get from our clients: 'Do what you feel is right.' This usually results in images that work well and need little work from us. Here we build long-term relations with photographers we can always trust.

And finally, the more detailed brief, where photos will be treated as raw material for further work by us. We do, however, try to build in a degree of freedom for the photographer into these briefs.

Contrast and playfulness are central to our way of working. This has led to our leitmotif and slogan: Baroque science fiction. Although classical approaches to type are the foundation on which we work, we explore what happens when rules are bent almost to breaking point, but still manage to hold together to create an emotional whole.

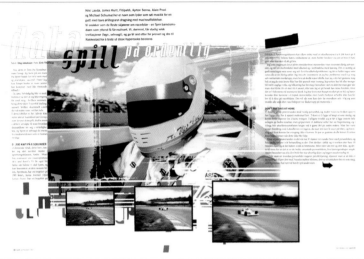

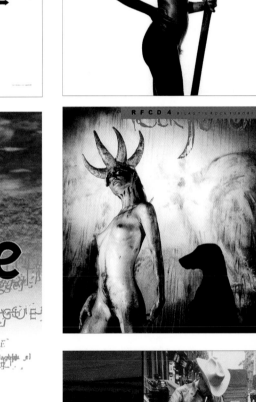

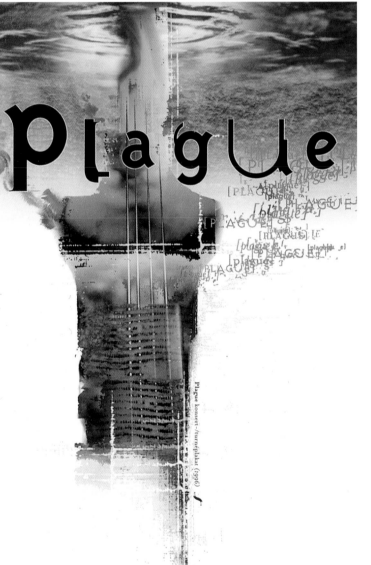

Plague konsert-/turnéplakat (1996)

New Wave

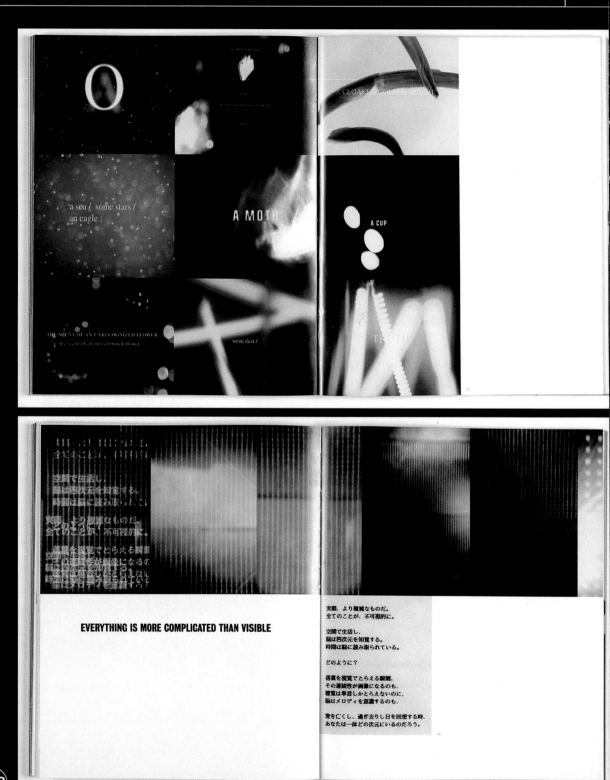

EVERYTHING IS MORE COMPLICATED THAN VISIBLE

実際、より複雑なものだ。
全てのことが、不可視的に。

空間で生活し、
脳は四次元を知覚する。
時間は脳に読み取られている。

どのように？

落葉を複覚でとらえる瞬間、
その連続性が画像になるのも、
聴覚は単音しかとらえないのに、
脳はメロディを意識するのも。

愛をじくし、過ぎ去りし日を回想する時、
あなたは一体どの次元にいるのだろう。

It surprised me to find that clients did not expect me to be a practicing artist. Where do they suppose it comes from?" Graham Wood.

"...all our work is about experience and the mapping of that experience; and for us Tomato is where we go to compare these maps. In effect, we bring a map (or maps) from one territory and overlay one upon another to see what happens. This is how our individual work evolves, and how we work together." (From *Process: A Tomato project*, published by Thames and Hudson,1996.)

The Future

Around 500 photographic images have been used in this book to make a simple point: images balance information/description/content and emotion/evocation/style. There is no such thing as an image which does not communicate both: information and emotion. Sometimes the balance tips towards content, and matters of style take second place. At other times, the imperative is to evoke a feeling, and the subject of the photograph is less important – style is uppermost.

The designer's task is to 'read' the image – to understand its predominant visual language – in order to assess its appropriateness for the communication task in hand (taking into account message, medium and audience.)

Different design disciplines (because of their communication role) typically stick to images within a certain area of the information-evocation spectrum. (See chapter 1).

Different photographers typically create images within a particular band on the spectrum. (See chapter 2).

Different graphic designers, too, by specialising in certain sectors or clients, have different expectations of where the balance can be struck. (See chapter 5).

There a number of sources for photographs (Chapter 3) and a large number of effects that can be created with them by placing them in the context of type, space, colour, graphic marks, other images, etc. (Chapter 4).

Successful designers maintain a *consistent* visual language right through a piece of work. The mixing of visual languages is equivalent to the mixing of messages: confusion will be the predictable outcome. And no piece of communication can make contact with a confused reader.

Successful designers have the ability to read an image – eyes, mind and heart open – and the ability to, similarly, read type, colour, proportion, etc. The designer serves the communication brief honestly by employing the *appropriate* visual language. Or, if the design group has a signature visual language, then the onus rests with the commissioner to use them for their appropriateness rather than their status.

Once a photograph is used in a work of design, its integrity is compromised. This happens even if the designer does not re-crop it, or re-scale it. The mere fact of being put in a certain position on a page of a certain proportion with type of a certain cut and colour of a certain hue will change the photograph. *The art of designing with photographs is to magnify strengths and compensate for weaknesses*. From this point of view the quality of an individual photograph is less important than the impact of the whole.

Understanding visual language, then, becomes the starting point for design. Some do so instinctively (and cannot think what the fuss is about); many need to practice a more conscious way of looking. This book attempts to point to a few characteristics of the visual language game...

The not-so-distant future

Without exception, the people interviewed in this book cited new technology as a powerful shaper of the future of not only photography, but also design.

The simplest and quickest images to get for this book were those that came down-line from designers and photographers in the UK and abroad – the future-minded, web-sited, e-mailed individuals. The next quickest were those that were supplied on disc – pages in which the images had been used were saved in eps format, compressed and delivered on disc. The next quickest were those pieces that had been photographed and a transparency supplied. The slowest were the actual printed items. (This represents the descending scale of technology.)

Eamon McCabe of the *Guardian* newspaper (page 22) talked about how the thousands of images available down-line had fundamentally altered the role of picture editor on a newspaper – and the concept of 'press photographer'.

Future predictions: Mike Dempsey (page 142).
Everything has been done. Computers have changed our perception of photography The day I watched a still from an Eisenstein film having its scratches removed by a retouching programme, I sat in wonder. Photographers are buying Macs and scanners, and will be doing their own manipulations. Originality will be down to the eye of the photographer and how they see the subject. What will succeed is the well-framed photograph, simple but beautiful and surprising. Technique is now available to all, so the style mags are now giving us the anti-fashion shot which looks amateurish, models in a drab setting, bounced flash. Are these photographers seen to be either young, raw and penniless? Or is this a new way of seeing? Individuals will ring the changes. There is such an array of possibilities.

Future predictions: Marius Renberg (page 146):
After the 'wild' early 90s, modernistic purity could see a strong revival. However, I believe we will be seeing much more of parallel cultural developments co-existing in the future. Subtopia will, hopefully, manage to jump about in this cultural mixture like a bobcat on heat.

Future predictions: Peter Bonnici (page 34):
Within the next five years, the major technological hitches of the internet will be largely overcome. It will be increasingly common to bundle in sound and video clips. When this point is reached, the majority of information communication conducted on the internet – goodbye product brochure. Designers will need to know as much about moving images and sound as they know about static images and colour. Those who stay in print will need to re-invent its role – one that complements the digital media and addresses areas it cannot. What will give rest to the mind and a lift to the soul?

Almost every photographer in this book has toyed with scanning and retouching technologies. David Kampfner (page 94), a member of the Association of Photographers in the UK, talks about the heated debates that range around the subject of the digital revolution. "I will shoot my images on a digital camera (when their quality improves), drop them onto my web-site; they're viewed by a remote designer who downloads the required images, places them into a Mac layout and ISDNs the page to the printer. No hard copy of my actual work exists anywhere in this process. The final image in print isn't strictly the photograph I took – it's a representation of it. It won't be long before even the printing stage gets by-passed and the image goes onto someone's web-site. Does that make me take photographs in a different way? At the moment it does not. But who knows how things will change?"

With this scenario a distinct possibility, what happens to copyright? The technology increases the opportunity and temptation for image piracy. It's currently possible to download an image off a stock library CD, retouch out the 'water mark', manipulate it beyond recognition – and the designer has 'acquired' a 'free' image.

With the current quality of internet technology and design, what happens to visual language? What happens to corporate identity? Why be satisfied with slowly reading a 'magazine' on something that looks like a TV when moving images and sound would suit it better?

This is usually the point at which someone mentions that the first thing they do to a piece of print is smell it. And others talk about the feel of it. For a designer, these are not good enough on their own – we want them to LOOK at it. What will people want to look at in the future? Re-view the 500 or so images in this book, which one can you look at again and again, each time getting more from it? If the medium is going to be static, then tomorrow's reader is going to need a different level of reward.

Index of contributing designers

Addison Design Ltd.
Peter Chodel
2 Cathedral Street,
London SE1 9DE, UK

T +44 (0)171 403 7444
F +44 (0)171 403 1243
ISDN +44 (0)171 378 6176

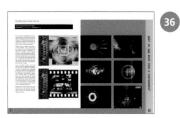

Dogs
David Fennel
7 Ledbury Mews North
Notting Hill Gate
London W11 2AF

T +44 (0)171 727 8866
F +44 (0)171 727 8899
email dogs@eastnet.co.uk
http://www.dogs.uk.com

Body Shop International PLC.
Jon Turner
Elsley Court
20/22 Great Titchfield Street
London W1P 7AD, UK

T +44 (0)171 208 7600
F +44 (0)171 436 7166

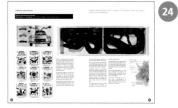

Dorling Kindersley
Stuart Jackman
9 Henrietta Street
London WC2E 8PS, UK

T +44 (0)171 836 5411
F +44 (0)171 836 7570
website http://www.dk.com

B*U*R*N*
Steve Williams and Tony Lee
1 Rowfant Mansions
Rowfant Road
London SW12 7AR, UK

T +44 (0)181 675 7601
F +44 (0)181 675 7601
M 0958 358 481
email moomoo@dircon.co.uk

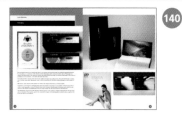

Lewis Moberly
Mary Lewis
33 Gresse Street
London W1P 2LP, UK

T +44 (0)171 580 9252
F +44 (0)171 255 1671
email lewismoberly@enterprise.net
ISDN 0171 631 3309

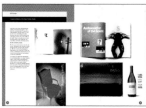

CDT Design
Mike Dempsey
21 Brownlow Mews
London WC1N 2LA, UK

T +44 (0)171 242 0992
F +44 (0)171 242 1174
ISDN +44 (0)171 404 7650

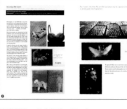

M&C Saatchi Limited
Andy McKay
36 Golden Square
London W1R 4EE, UK

T +44 (0)171 543 4500
F +44 (0)171 543 4501

**Though not strictly designers,
two contributors merit a listing in this section**

Guardian
Eamon McCabe, Picture Editor
119 Farringdon Road, London EC1R 3ER, UK
t +44 (0)171 713 4159 F +44 (0)171 239 9951
ISDN +44 (0)171 713 7496

We wish to thank the many designers who have shared with us their thoughts on the use of photographs in design. The variety of visual voices employed has helped to illustrate the fundamental premise of the book.

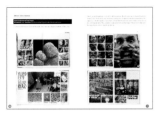

M&Co Labs Inc.
Tibor Kalman
180 Varick Street
9th Floor
New York NY 10013, USA

T +1 212 645 5787
F +1 212 645 6599

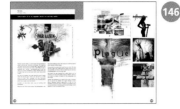

Subtopia
Møllergt. 32a
N - 0179 Oslo
Norway

T +47 (0)22 20 43 10
F +47 (0)22 20 43 13
email subtopia@online.no

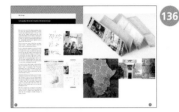

ML Design
Martin Lubikowski
203 Blackfriars Foundry
156 Blackfriars Road
London SE1 8EN, UK

T +44 (0)171 721 7254
F +44 (0)171 721 7256
email lubikowski@aol.com

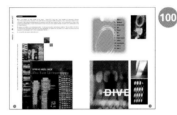

System Gafa
Yuki Miyake
13 Stoney Street
London SE1 9AD, UK

T & F +44 (0)171 403 7067

Michael Nash Associates
Anthony Michael
42-44 Newman Street
London W1P 3PA, UK

T +44 (0)171 631 3370
F +44 (0)171 637 9629
email mna@mna.globalnet.com

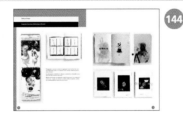

Tolleson Design
Steve Tolleson
220 Jackson, Suite 310
San Francisco
CA 94111, USA

T +1 (0)415 626 7796
F +1 (0)415 512 6767
email stolleson@tolleson.com

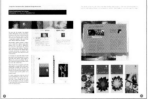

Quadrant Design Associates
Peter Bonnici
84 Long Lane
London SE1 4AU, UK

T +44 (0)171 407 0261
F +44 (0)171 403 6713
quadrantdesign@btinternet.com

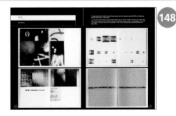

Tomato
Graham Wood
29-35 Lexington Street
London W1R 3HQ, UK

T +44 (0)171 434 0955
F +44 (0)171 434 0935
email mail@tomato.co.uk

Susan Tilley Food Art Australia Pty. Ltd
25 Airlie Avenue, Prahran East,
Victoria 3181. Australia
T & F 0061 3 9510 1631
email Tilley.Food.Art@onaustralia.com.au

Index of contributing photographers

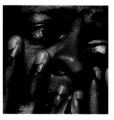
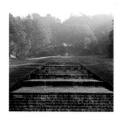
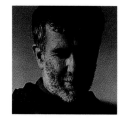
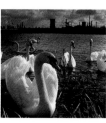
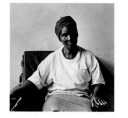
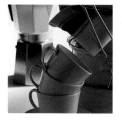
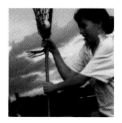
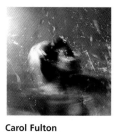
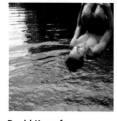

We wish to thank all the contributing photographers for allowing us free access to their images. The page numbers in circles show where the images have been used to make a key point. Other pages where the particular photographer's images have been used are also listed.

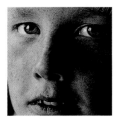

Charles Milligan
20 Tredown Road
Sydenham
London SE26 5QH, UK
T +44 (0)181 676 0349
M 0831 391 175

John Street
11 Margaret Street
Brighton East 3187
Victoria, Australia
T +61 (0)3 9592 1332
F +61 (0)3 9690 8906
M 0412 48 41 48

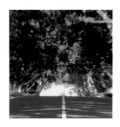

Andrew Hall / Peter Bailey
81 Leonard Street
London EC2A 4QS, UK
T +44 (0)171 739 4411

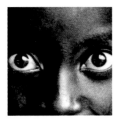

Sebastaio Salgado / Network
3-4 Kirby Street
London EC1N 8TS, UK
T +44 (0)171 831 3633
F +44 (0)171 831 4468
email netphoto@compuserve.com

Simon Farnhell & Jennie MacKay
White Backgrounds
Unit 2, 90A Camberwell Road
London SE5 0EG, UK
T +44 (0)171 703 2202
M 0374 674 733

Thanks to the stock libraries that have allowed us to use their work:

Oxford Scientific Films
Lower Road
Long Hanborough
Oxfordshire OX8 8LL, UK
T +44 (0)1993 881881
F +44 (0)1993 882 808

Photonica
10 Regents Wharf
All Saints Street
London N1 9RL, UK
T +44 (0)171 278 4117
F +44 (0)171 278 4118

Roger Viollet
6 Rue de Seine
75006 Paris, France
T +33 (0)1 55 42 89 00
F +33 (0)1 43 29 71 88

The Stock Market
360 Park Avenue South
New York NY 10010, USA
http://www.tsmphoto.com

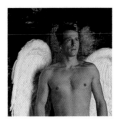

David Scheinmann
17 Golden Square
London W1R 4AH, UK
T +44 (0)171 439 3231
F +44 (0)171 434 3463
M 0410 130002

Russ Widstrand / Debut Art
30 Tottenham Street
London W1 9PN, UK
T +44 (0)171 636 1064
F +44 (0)171 580 7017
email widphoto@silcom.com
http://www.silcom.com/~widphoto

Duncan Smith
50a Rosebery Avenue
London EC1R 4RP, UK
T +44 (0)171 837 6873
F +44 (0)171 278 7869

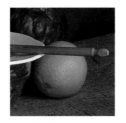

Peter Williams
68 Bolingbroke Grove
London SW11 6HD, UK
T +44 (0)171 228 2298
F +44 (0)171 801 0965

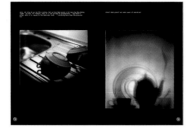

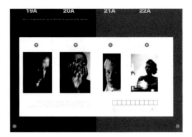

14 Harrods
15 Tim Imrie

16 Duncan Smith
17 Barbara & Zafer Baran

18 James Hunkin; Tony Latham
19 Charles Milligan; Barbara & Zafer Baran

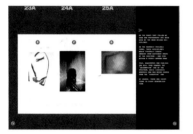

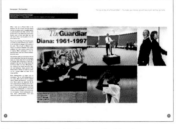

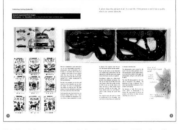

20 Hannah McPherson; Thomas Gray
21 Carol Fulton

22 Ian Waldie **23** Shaun Smith; Eamon McCabe; Tom Jenkins

24-25 Picture copyright **Dorling Kindersley**

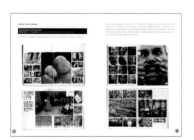

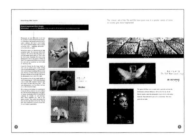

Page 26: Top spread, left to right, top to bottom.**1.** Refugee en route from Mozambique to Malawi. Guenay Ulutuncok/Laif Photo Agency **2.** Mexico City **3.** Pascal Maitre/Saba/Grazia Neri **4.** Jean Claude Coutausse/Contact/Grazia Neri **5.** Pope John Paul II at Rome's international airport. M.Siragusa/Contrasto **6.** Pygmy camp, Congo. Gerald Buthaud/Cosmos/Grazia Neri **7.** Wooden clogs, Japan. Paul Chesley/Grazia Neri **8.** A Turkish prisoner just released by the Peshmergas, guerilla Kurds based in Northern Iraq. Patrick Robert/ Sygma/Grazia Neri **Large Image**, The developing foot of an 11-week-old embryo. Lennart Nilsson **1.** In the Pocono mountains, Pennsylvania, USA. Peterson/Saba/Contrasto **2.** Peter Byron/Black Star/Grazia Neri **3.** Member of the New Rasputins, a russian cult offering seminars said to liberate the emotions. Frederique Lencaigne/Luigi Volpe **4.** GJ Images/The Image bank **5.** French high heel, Paris, France. C.Vormwarld/Sygma/Grazia Neri **6.** Child at a Tutsi refugee camp in Rwanda. Liz Gilbert/Sygma/ Grazia Neri

Bottom Spread: left to right, top to bottom.**1.** Community school at Crossroads squatter camp, South Africa. Chris Steele Perkins/Magnum/ Contrasto **2.** Kayapó people of Brazil. Sue Cunningham/Sue Cunningham Photographic **3.** Siberia. Tom Babovic/Black Star **4.** Karonic verse in Arabic script, painted on the chest of a heroin addict

at a drug treatment clinic at Kuala Lumpa, Malaysia. Steve Raymer/National Geographic Image Collection **5.** Calligraphy competition in Tokyo. Alan Evrard/Marka **6.** Nuclear reactor control room. Washington, USA. Matthew Neal McVay/Marka **7.** Dogon symbols drawn in sand grid in the village of Bongo, Mali. The symbols are interpreted by Dogon diviners. José Azel/Contact/Garazia Neri

page 27 Top spread: Top to bottom, left to right**1.** South Africa. David Turnley/Black Star/Grazia Neri **2.** Grazia Neri **3.** Weightlifting finals, Barcelona Olympics. Olympia **4.** Funeral in Sicily. Titolo/Shoba/Contrasto **5.** Handisports tournament, Paris. Richard Martin/Vandystadt/ Image Bank **6.** Haitian man at mother's funeral. Maggie Steber/JB Pictures/Grazia Neri **7.** English football fan in Cagliari, Italy. Eligio Paoni/ Contrasto **8.** Nguyen Thi Lop, the widow of Nguyen Van Lem, killed during Tet offensive, Vietnam. Philip J. Griffiths/Magnum/Contrasto **9.** Famine in Somalia. Chris Steele Perkins/ Magnum/Contraso **10.** Croatian child at the funeral of his father, a casualty of the war wit the Serbs. Haviv/Saba/ Contrasto **11.** Smiling girl, Sierra Leone. Abrahams/ Network/Grazia Neri **12.** Baby in bath, France. Glame/Sygma/Grazia Neri **13.** At the twenty-fifth anniversary of the Woodstock rock festival, New York, NY, USA. R. Benali/Olympia

Bottom spread: 1. Micronesia. Michael Fiedel/Grazia Neri **2.** Interior of ABC Carpet & Home store. New York City, USA. Courtesy of ABC Carpet & Home **3.** The acquittal of four police officers who assaulted a black motorist in Los Angeles, USA leads to mass looting, rioting and the death of 58 people. Kirk McKoy/L.A. Times **4.** Enterprise Square mall, Oklahoma City, USA. Jeff Jacobson **5.** Japanese travel kit consisting of typical national foods, including nori (dried seaweed). Sergio Merli **6.** workers at the Honky Dory Toy Factory in the Guandong Province of China produce handmade Santa Claus dolls. Michael Wolf/Visum/Grazia Neri **7.** Brain researcher. Tokyo, Japan. Pagnotta Dafonseca/Contrasto **8.** Marka **9.** Buenos Aires, Argentina. Fernando/The Image Bank

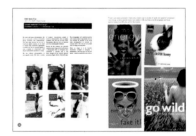

28 Javier Vallhonrat; Donna Trope; Henrik Thorup-Knudsen; Jo Hassel **29** The Douglas Brothers; **David Scheinmann**; Tim O'Sullivan

30 Stock **31** (Clockwise) Eric Richmond; Stock; Martyn James Brooks; Sandro Hyams

We wish to acknowledge the work of all the photographers whose images have made this book possible. Where images have not been credited, this indicates that they have been either taken from the existing pool (stock, etc) or have been taken by the designers themselves. **Names in bold indicate contributing photographers with other pieces in the book**

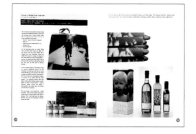

32 Toby Glanville; Matthew Donaldson
33 (counterclockwise) stock; Dominic Ford; Matthew Donaldson

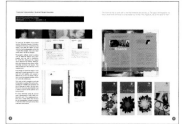

34 Carol Fulton; James Hunkin
35 David Kampfner (*border own photos*); (bottom row) *Copyright-free CDs*

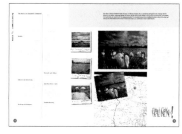

70-71 Patrick Lichfield and assistant, Pete Kain

74-75 Alan Marshall

76-77 James Hunkin

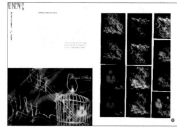

78-79 Thomas Gray

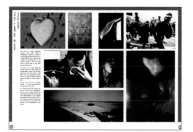

86 Jason Love; Jo Baker; Libi Peddler; Richard Glover **87** (Clockwise) Brian David Stephens; David Townend; Dominic Davis; Anne Rogers **Agency: Refocus**

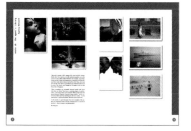

88 Christopher Pillitz; Don Miller; Roger Hutchings **89** (Clockwise) Mark Power; Jack Picone; Peter Jordan; Peter Jordan; Joanna Morrison **Agency: Network**

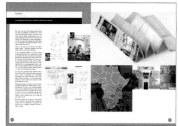

136 Oliver Benn; Julian Barton
137 *Own photography; stock images for map*

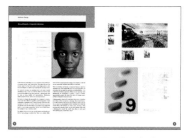

138 Malcolm Venville **139** Mike Abrahams/ **Network**; Michael Banks

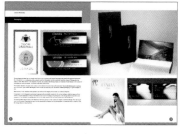

140 Laurie Evans; Robin Broadbent
141 (Clockwise) Alan David Tu; Tim Platt; Martyn Thompson

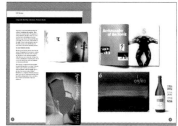

142 Andy Earl; Lewis Mulatero
143 (Clockwise) Uli Weber; David Timmis; **Barbara & Zafer Baran**

Photographer Credits / Acknowledgements

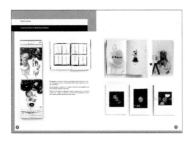

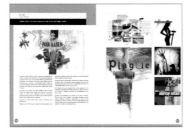

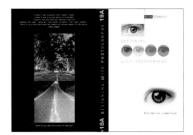

144 Karen Collin;, John Casad;, Nickolay Zurek **145** Tim Brown; Everard Williams, jr; Robert Schlatter

146 Per Heimley **147** Erik Thallaug; Per Heimley; Per Heimley; *supplied*; Per Heimley

Back cover (Top) Andrew Hall; (bottom) Barbara & Zafer Baran 'Yorkshire', 1983 (personal work)

Thanks to the agents who have given us permission to represent their photographers in this book

Debut Art
30 Tottenham Street
London W1 9PN, UK
T +44 (0)171 636 1064
F +44 (0)171 580 7017
Representing Russ Widstrand (p56)

(87) **Network**
3-4 Kirby Street
London EC1N 8TS, UK
T +44 (0)171 831 3633
F +44 (0)171 831 4468
email netphoto@compuserve.com
Representing
Jillian Edelstein (p44)
Sebastaio Salgado (p58)

Peter Bailey Company
London W1
T +44 (0)171 935 2626
F +44 (0)171 935 7557
Representing
Tim Imrie (p15)
Andrew Hall (Back cover)

(86) **Refocus**
11 Poplar Mews
London W12 7JS, UK
T +44 (0)181 743 0588
F +44 (0)181 746 0242